SAMUEL BOURNE

Images of India

SAMUEL BOURNE
Images of India

By Arthur Ollman

UNTITLED 33

THE FRIENDS OF PHOTOGRAPHY

UNTITLED 33 : This volume is the thirty-third in a series of publications on serious photography by The Friends of Photography. Some previous issues are still available.

THE FRIENDS OF PHOTOGRAPHY, founded in 1967, is a not-for-profit membership organization with headquarters in Carmel, California. The programs of The Friends in publications, grants and awards to photographers, exhibitions, workshops and lectures are guided by a commitment to photography as a fine art, and to the discussion of photographic ideas through critical inquiry. The publications of The Friends, the primary benefit received by members of the organization, emphasize contemporary photography yet are also concerned with the criticism and history of the medium. They include a monthly newsletter, a quarterly journal and major photographic monographs. Membership is open to everyone. To receive an informational membership brochure, write to the Membership Coordinator, The Friends of Photography, Post Office Box 500, Carmel, California 93921.

ISSN 0163-7916; ISBN 0-933286-36-8
Library of Congress Catalogue No. 83-81932

Cover: *Ancient Brahminical Temple in the Fort, Gwalior, Another View Showing the Entrance*, 1865. (Bourne #1330.)

Designed by Peter A. Andersen

This book is dedicated to Rosella and Rebecca.

A.O.

PICTURE CREDITS

The images reproduced in this book appear courtesy of the following collectors and institutions.

Carpenter Center for Visual Arts, Harvard University, *plates 8, 11, 12, 16, 18*; Robert Hershkowitz, *figures 4, 5, plates 5, 15*; Nottingham Society of Artists, *figure 6*; Arthur Ollman, *plates 6, 7, 9, 10, 13, 14, 19-25*; Howard Ricketts, *figure 1, plate 17*; Royal Photographic Society, Bath, *figures 2, 3*; Wright Art Center, Beloit College, *plates 1-4, cover.*

ACKNOWLEDGEMENTS

SAMUEL BOURNE MADE many important contributions to the development of photography during the 19th century as one of the first to record photographically the outlying regions of the British Empire. His photographs were frequently published during his lifetime, and have been included in a number of recent anthologies, but this book is the first monographic presentation of Bourne's work. It is a pleasure to be able to include it as a part of The Friends of Photography's *Untitled* series.

The greatest thanks must go to Arthur Ollman for his enthusiastic interest in Bourne's photographs, for his skillful investigation of Bourne's life and work, and for his informative introductory essay to this volume. His careful research in both the United States and England has given him unusual insight into the work of a major figure in photography.

Many individuals and institutions must be acknowledged for their contributions to the book. For their continuing support and generosity throughout the project, thanks and appreciation go to Rosella Stern, Rebecca Felsenfeld, Leah Goldman, Bill Jay, Sean Thackery, Van Deren Coke and Ansel Adams. Thanks also to Mark Haworth-Booth, of the Victoria and Albert Museum, London; Ray Desmond, of the India Office Library, London; the National Endowment for the Arts, San Francisco Camerawork; the Museum of Photographic Arts, San Diego; the Nottingham Public Library, and the Royal Photographic Society, Bath, England.

For their willingness to loan the photographs contained in this book, thanks go to Barbara Norfleet, of the Carpenter Center for the Visual Arts, Harvard University; Michael Simon, of the Wright Art Center, Beloit College, Beloit, Wisconsin; Robert Hershkowitz, Arthur Ollman and Howard Ricketts. Thanks also to Vern Heger, and Larry Booth and Jane Booth, of the San Diego Historical Society, for making the copy prints used for reproduction.

I would also like to thank the following members of The Friends of Photography staff for their contributions to the book: David Featherstone and Claire Peeps, for their editorial expertise; Peter A. Andersen, for his design of the volume; and Pam Feld, for her administrative assistance. Thanks also to David Gardner and the staff at Gardner/Fulmer Lithograph, for reproducing the photographs with such clarity and in such close facsimile with the original albumen prints.

James Alinder, *Editor*
The *Untitled* series

INTRODUCTION

ONE DAY IN late August, 1866, Samuel Bourne stood on the glacier of the Manirung Pass, 18,600 feet above sea level in the Indian Himalayas, and made three photographic views of the pass and surrounding mountains that expanded the known frontiers of both Victoria's England and the medium of photography. It was the culmination of years of photographic exploration in India. Never before had a photograph been exposed from such an elevation. A young Englishman, Bourne would soon return to Nottingham to become a successful manufacturer, family man, amateur watercolorist and poet.

It is clear from the photographs included in this volume that Bourne was an excellent artist as well as a skilled technician, but it is because he was an exceptionally well-organized individual that a corpus of his photographs and writings are available for study. He made thousands of negatives in India. Through his images, his numbering of the plates, his careful cataloguing and labeling and the extensive narrative reports of his travels, Bourne has provided an amazingly complete picture of his productive life there.

Born on October 30, 1834, in the Midlands of England, Samuel Bourne spent his youth on the family's farm. In 1851, when he was seventeen, he saw a daguerreotype of an uncle that had been taken in one of Richard Beard's London portrait studios. Strongly taken by the fidelity of the likeness and the fineness of the tonal gradations, Bourne marveled that such a miracle was possible and hoped to be able, one day, to accomplish similar results. Two years later he acquired a camera and began to make portraits of friends and relatives.

Indeed, European society was intrigued with photography. Thousands of amateurs were attracted by this wonderful new technology, and by the 1850s photographic clubs had formed all over the continent. Journals of photographic interest informed middle and upper class hobbyists of the newest procedures and products, and many of these individuals made enormous contributions to the development of the medium. England's love affair with photography was officially sanctioned through the great interest and patronage of Queen Victoria herself. She was often photographed, and her government sponsored photographic projects to illustrate interesting and exotic aspects of the Empire.

In 1857, Bourne moved to Nottingham to begin a career as a bank clerk, and by 1858 he was photographing landscapes, cityscapes and portraits in and around the town. That same year the Nottingham Photographic Society was formed. For one of their first exhibitions, the Society selected more than 2,000 photographs from all over Europe; works by Roger Fenton, Francis Frith, Gustave LeGrey, the Bisson Frères and Oscar Rejlander were included. At the same time, the society also sponsored a competition among its members. George Shadbolt, editor of the *Photographic Journal* and president of the North London Photographic Society, judged the competition and awarded Bourne second prize. Bourne's excellence, however, was primarily technical. In his comments about the show, Shadbolt pointed out that Bourne was already a meticulous craftsman, but his pictures possessed "very little architectural interest [and] were totally destitute of every vestige of life" (*Nottingham Review*, January 7, 1859).

In 1860, Shadbolt saw more of Bourne's photographs in an exhibition in London, and indicated in the *British Journal of Photography* that Bourne had made "wonderful progress since last year in artistic excellence" (February 1, 1860). The glass plates Bourne made during this period show excellent exposure and careful composition, though they seem conservative from a design standpoint when compared with his later efforts. The skies were often heavily painted with opaque lacquers in an attempt to avoid spotting and streaking.

The Nottingham Photographic Society was in its second year of existence when Samuel Bourne was asked to deliver a paper. On January 31, 1860, he read "On Some of the Requisites Necessary for the Production of a Good Photograph," to the Society. The paper was subsequently published in the *British Journal of Photography*, the successor to the *Photographic Journal*. Although he was only twenty-six years old, Bourne was thought of by his fellows as being something of a local master, a spokesman and authority on the art. His writing style seems over-eager and a bit self-satisfied, even by Victorian standards, but he is absolutely confident in his presentation. These qualities are characteristic of his writings and actions throughout his life. In this early prose self-portrait he not only outlined characteristics for success, but also indicated how he handled

the criticism of others. While remarking that much effort is necessary to master the technical aspects of the medium, Bourne noted that:

> The young photographer in his eager desire to master these, very frequently pays no attention to the artistic properties of his pictures. . . . Such I freely confess, was the case with myself, . . . so having in some degree mastered the difficulties of manipulation, my ambition spurred me on to attempt to produce pictures which should be as much admired for their artistic qualities, as for their excellence viewed in a purely photographic light.
>
> (February 24, 1860.)

Samuel Bourne had already shown an interest in traveling to lovely, out of the way places to make photographs of what he felt was picturesque. He had also shown great respect in his writings for those photographers who brought back pictures from distant and exotic lands. Although his exact motivation is unknown, Bourne clearly had a desire to join these adventurers. In late 1862, Bourne sailed to India with all of his photographic equipment. On February 16, 1863, the *British Journal of Photography* announced his trip, and their plans to publish a series of papers Bourne would send them on his "Experience in the East."

No part of the Empire was more closely tied to England than was India, the largest jewel in Victoria's crown. The Queen never visited India, but she enjoyed curries and learned Hindustani; "India," she wrote in the 1850s, "should belong to me." Thousands of British citizens went to India to settle, to extract wealth and to tour. They had various exotic fantasies about the country, and knew that there they would be the ruling class, able to cultivate the airs of the privileged, but they rarely understood the land and the people. In the early days of the East India Company, during the 17th century, British interest in India was primarily trade, but by 1757 the British controlled much of India. They spent the next hundred years usurping the land, draining huge resources of wealth and manipulating the Indian economy to secure its complete dependence on England. In fact, the British Industrial Revolution was bolstered by this influx of Indian wealth.

The British did send social reformers to India, hoping that, within a generation or so, the "respectable classes" of India would be, according to Francis Hutchins' 1967 analysis of British India, *Illusion of Permanence*, "Christian, English speaking, free of idolatry and actively engaged in the government of their country. Increasingly, though, England held India by force. In 1857, near Delhi, Lucknow and Cawnpore, the Sepoy Regiments of the Indian Bengali Army rebelled. The causes of the war were numerous and complex; but, for the Indians, the rebellion was a war of liberation. The British refer to this incident as the Mutiny of 1857. The cruelties and atrocities committed on both sides indicate that tensions had grown extraordinarily high, but after months of defeats, the British

were able to contain the "rebellion." Victoria responded to the rebel actions by abolishing the East India Company and its administration of India. She established direct crown rule, indicating that England had no intention of letting go of its holdings. With the abolition of the East India Company, the whole style of British rule changed, and those who settled there came with the desire to control rather than reform.

By the 1840s, photography had arrived in India much as it had arrived elsewhere. As a portrait medium competing with studio portrait painting in major cities, it replaced many draughtsmen with photographers by the mid-1850s. In October of 1854, India's first photographic society was formed in Bombay by Britons. The photographers, of course, had no easy time of it. Conditions were bad; heat and dryness, bad water and poor supplies prevailed. To add to the difficulties, the Pacific & Orient Steamship Line refused to transport collodion to India because the active ingredient was also the explosive ingredient in smokeless gunpowder!

WHEN SAMUEL BOURNE arrived in Calcutta in mid-January, 1863, he wrote an article for the *British Journal of Photography* on "Photography in the East," in which he recognized that photography was not new to India.

> From the earliest days of the calotype, the curious tripod, with its mysterious chamber and mouth of brass, taught the natives of this country that their conquerers were the inventors of other instruments besides the formidable guns of their artillery, which, though as suspicious perhaps in appearance, attained their object with less noise and smoke. From the untrodden snows of the Himalayas to the burning shore of Madras the camera is now a familiar object. (July 1, 1863.)

Bourne's Victorian attitudes toward the Indian people are gradually revealed in his writings. In this same article, he described a trip to the customs house.

> Carefully packed as everything had been in London, I found many precious articles smashed in a pitiless manner —all done, as I verified by my own inspection, by the recklessness of the coolies in the "godowns" of the custom house. Four of these fellows get a package on their heads, carry it to its destination, and then at a given signal spring from under it. The consequence is that anything which can break does break, and the unhappy owner has the consolation of pocketing the loss and kicking the coolies, for which he gets fined fifty rupees.
>
> (BJP, July 1, 1863.)

Bourne soon left Calcutta to travel twelve hundred miles northwest to Simla, located in the foothills of the Himalayas, where the British Viceroy maintained a picturesque summer residency.

These served as the seat of government for six months each year and made Indian access to the governmental process difficult. Several of these mountain "Hill Stations" or resorts were used by those of rank or position to avoid the unbearable summer heat of the lower elevations. From these lofty elevations, clearer, cooler heads could administer India.

In his continuing articles for the British journal, Bourne not only described his photographic adventures, but gave his readers a feeling for the Indian landscape and for village life. The first part of his trip to Simla was by train.

> Now and then we whirl past a village of miserable mud huts, swarming with sprawling nude children, who, together with the men and women, suspend their operations to gaze in mute astonishment at the flying train. I tried to imagine the sensations with which these poor ignorant, semi-barbarous inhabitants of the plains must for the first time have beheld the flying engine dragging its retinue of carriages. (BJP, July 1, 1863.)

After leaving the train at Benares, he pronounced the area quite suitable for photography. The bazaars, narrow streets, temples and mosques, and the river Ganges appealed to his sense of the picturesque, but the native customs disturbed him.

> I witnessed the ceremony of the burning of two dead bodies. Five or six savage-looking men were heaping wood on the blazing piles, but I could discern through the flames the roasting skull and feet of one of the bodies. One of them was that of a woman, whose husband stood by evidently regarding the horrid spectacle with the highest satisfaction. On every hand you are reminded of the religious zeal of this deluded people. (BJP, July 1, 1863.)

These attitudes were to be expected; Bourne was a new arrival, a young man who could not have been considered worldly. As he undertook his Grand Tour, he immediately adopted the standards and attitudes of other British in India, which after the 1857 Mutiny were those of superiority and disdain.

Indeed, England was his model of excellence; and his desire, following the tradition of British 18th century landscape painting, was to transport the picturesque English scenery he loved to the clear and brilliant light of India.

> I have no doubts that in some parts of the Himalayas grand and striking views are to be found, as I hope ere long to verify; but they would consist chiefly of ravines, passes and mountain ranges—without verdure, without foliage, and without water; and a photograph minus these three elements must possess very striking compensation indeed to render it a pleasing and enjoyable picture. (BJP, September 1, 1863.)

Bourne remained interested in the picturesque throughout his life, but the raw materials that were to form his Indian work were initially beyond his comprehension. As is often the case with art, the most interesting productions seem to stem from mutations of an original idea. In time, Bourne did allow the forms of the Indian landscape to dictate his compositions, and some of his most lasting work is without the three elements he had once considered essential.

Like all photographers in India, Bourne had some major technical obstacles to surmount. In his first *British Journal of Photography* letter of May 5, 1863, he indicated that he was plagued with red spots on his albumen papers during printing. He threw out his first batch of paper and tried another, but the results were the same. He changed the strength of the silver solutions, expanded and contracted the time used for developing and sensitizing the paper and substituted chemicals, but the spots continued, destroying the sharpness of the picture and preventing proper toning. This problem occurred during a very hot and dry period of the year. During several days of intense rain, he stopped printing in his dark tent; and when he returned to work, the weather had turned cool and he found no more red spots. "I almost leaped for joy. . . . The conclusion was irresistible; it must be owing to the change in the atmosphere—to the moisture, in fact, produced by the rains." By suspending the paper to be used the next day in a damp room overnight, he encountered no more red spots.

One of the challenges Bourne faced in India was the use of the "wet plate" collodion process. Although it was the finest method available, it was a difficult process to employ. Since it only remained sensitive when wet, the coated emulsion could not dry out during preparation, exposure or development. Bourne was an excellent practitioner of the wet plate process, despite the fact that he chose to execute it in some of the world's most difficult terrain. Imagine performing the following ritual in a dark tent on the side of a mountain at 10,000 feet. After a thorough washing, a glass plate was very evenly coated with collodion (a mixture of gun cotton dissolved in alcohol and ether) in which potassium iodide had been dissolved. In a dark tent, the plate was then sensitized by a five-minute dip in silver nitrate. It emerged a creamy color, was drained, and then placed in a plate holder while wet. This was put into the camera for exposure. After exposure, the plate was returned to the dark tent, where a solution of pyrogallic acid or protosulphate of iron was poured over it. Development was rapid, and when judged complete, the plate was rinsed in water. Potassium cyanide or sodium hyposulfite was used to dissolve the unexposed silver salts as a clearing bath. After a final washing, the plate was either air or heat dried; a varnish was added to protect the surface from damage.

Bourne certainly enjoyed proving that he was up to the rigorous challenge of working in India, of pushing to do his work under difficult circumstances and, by his conduct, setting a standard for the proper English gentleman in India. Bourne sought to impose the logic of the most advanced Western technology at his command as well as to apply his romantic

aesthetic to the uncharted Indian wilderness, and to add to the English awareness of the corners of the Empire by bringing back clear pictorial evidence. His aesthetic concerns were not, of course, innate in the landscape, but were determined by his culture, education, language and conventions. These concerns were imposed on a randomly observed natural environment, where specific elements were assigned relative merit based on his aesthetic perceptions. The subject matter of his photographs thus serves double duty—first, as itself, with no other meaning; and, second, as a representation of his picturesque aesthetic stance.

The rectangle that frames a photograph is an abstraction, a shape not readily found in nature; a window from behind which one may safely view a potentially threatening world, one that allows a rational organization of the randomness of nature. If this frame is imposed on rugged mountains, they become mere lines to compose; glaciers become areas of light and shade; buildings and streets become objects to balance; a Bengali porter is but an artful counterpoint.

The Victorian appreciation of logical spatial relationships is seen in Bourne's very rational attitude toward his work. He imposes the frame on the Himalayan wilderness in a nearly transparent way, and it is difficult to see that he is not simply recording information dispassionately. His understanding of both the Indian topography and his own aesthetic attitude is so complete that we feel his sense of control, or understanding of the immenseness. The land seems vast yet approachable, wild yet picturesque. The Himalayas as presented by Bourne are not threatening, they are conquerable and obtainable; his images were the product of advanced technology and clear aesthetics, suitable for Victoria's finest album.

The British awareness of what was contained within the confines of the Empire was often tied closely to the photographic evidence they saw. Photography was greatly admired for its apparent capacity of recording dispassionately whatever was presented to it, but photography was not simply an innocent observer. Photographs were heavy ammunition in the arsenal of Victorian British thought concerning India. Though Bourne traveled in India's wilderness as well as in its largest cities, we see very few photographs of Indians. When they do appear, they are artfully placed within many images for scale, or to make a scene seem more authentic. They are presented, as some English had always assumed, as incidental to the real scope of India; quaint and colorful to be sure, but not nearly as important as the real estate.

One reason so much Bourne material remains is that after he had been in India for a number of years, he established outlets for his pictures in Europe and all over India, distributing his photographs through Marion & Co., of Soho Square in London, which also had stores on the Continent and represented other photographers. Individuals who wanted photographs of exotic lands could go to these retailers and choose photographs illustrative of their concerns; they usually had little interest in the identity of the photographer. It was common for people who had recently returned from a trip to collect photographs of the locales they had visited, assemble them into albums or travelogues and display them prominently in their drawing rooms for family and visitors to see.

As a result, numerous albums can still be seen that contain Bourne photographs along with images taken by such photographers as Rust, Laurie, Shepherd, Frith, Tripe and Thompson. Since very few tourists traveled to the high Himalayas, preferring to visit the principal cities of India, a majority of the surviving Bourne prints in these albums are of more frequently seen areas, such as the Taj Mahal, Temples in Benares, Agra, Delhi and sites of the Sepoy Mutiny in Cawnpore and Lucknow. The photographs Bourne made in the wilderness found less of a ready market; they were not printed as often. Although they are among his greatest images, they are rare today and difficult to locate.

During Bourne's seven years in India, he made three major Himalayan expeditions. Each journey had its own goals and distinctive character, and after each he wrote a narrative of his adventures that was published in the *British Journal of Photography*. These articles reflect the differences in his approach both to his expeditions and to the way he wished them to be understood by the public. In a great many published accounts and letters of travel in India and in other areas of the Empire, a narrative style emerged that combined a factual reporting of the journey with a strongly exaggerated dramatization of the hardships encountered. One writer is attacked and nearly killed by thieves; another has a boat capsize and all aboard "nearly come to grief." Scarcely any account written by Englishmen from India in those years lacks this narrative device, and Bourne's letters are no exception. While life in British outposts was not difficult, with good food, good clubs and an

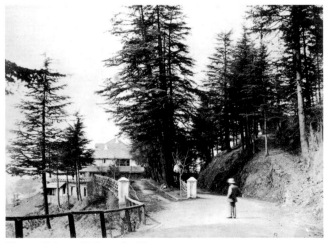

Figure 1. Oakover, Simla, 1963. (*Bourne #1.*)

active social and sporting life, the normal Briton found that outlying areas were very primitive. In addition, the climate in some parts of India is truly among the earth's least hospitable.

Wonderful examples of Victorian narrative, Bourne's letters are full of adventure, close escapes and hardships. They detail his technical procedures, offer advice to photographers and illustrate his ability to overcome unbearable harsh environmental and logistical conditions. They are humorous, anecdotal and witty, as well as intelligent, intolerant and insightful. Richly informative, they sometimes describe the exact circumstances in which he made many of his finest photographs.

Once Bourne adjusted to hill station life in Simla in early 1863, he began to establish friendships and professional contacts, and to understand the technical solutions needed to overcome the problems of using the wet plate process in India. His production of about 180 photographs in approximately six months in Simla was easy compared to the kind of effort he was to exert in the Himalayan wilderness:

> To spend a holiday rambling with the camera amongst the mountains of North Wales or through the Highlands of Scotland—(I can speak from experience)—is one of the pleasantest things imaginable. But in these wild and untrodden Himalayas there are no comfortable hotels where the tired photographer after his day's ramble may lounge at ease and refresh his inner man with all the luxuries of a well-spread table; . . . no town or village within distance where he may replenish his broken ground-glass, or procure a fresh supply of some exhausted chemical. (BJP, February 2, 1864.)

LEAVING THE SETTLED life of Simla, Bourne set out on July 29, 1863, for his first major Himalayan trek, one which would test his physical endurance, his photographic precepts and his ability to adapt the Victorian narrative form to his own ends. Drawing on his experience during more than two months of travel, he sent a long letter, "Ten Weeks with the Camera in the Himalayas," to the *British Journal of Photography* on November 7, 1863. It was published in two installments, in the February 1 and February 15, 1864, issues.

Following the road from Simla to Chini, a village 160 miles to the northeast, Bourne used a team of thirty coolies to carry his cameras—one using plates 10 x 12 inches, the other 4½ x 8 inches—chemicals, dark tent, bedding and provisions. Traveling on an easy, newly opened road for the first hundred miles, the expedition had no trouble making progress. They passed dozens of waterfalls swollen by the rains, huge forests of noble deodar trees and enormous cliffs rising thousands of perpendicular feet above the trail and often dropping off just as precipitously on the other side.

After sixteen days marching, Bourne reached Chini, nine thousand feet above sea level. Sitting on a perch three thousand feet above the Sutlej River, Chini faces two mountains, the Kylass and Raiding peaks, which rise to twenty-two thousand feet. After waiting for clouds to pass Bourne made a three-plate panoramic view at Chini.

For three weeks he photographed the great landscape along the Sutlej River. His first difficulty here was to find a place to stand in the precarious landscape with room nearby for his dark tent. The problem then became an aesthetic one: how could one compress such vastness onto a few square inches of collodion?

> With scenery like this it is very difficult to deal with the camera: it is altogether too gigantic and stupendous to be brought within the limits imposed on photography. . . . But my anxiety to get views of some of these fine combinations of rocks and water often induced me to leave the regular track and put myself and instruments in the greatest danger by attempting an abrupt descent to some spot below, indicated by the eye as likely to command a fine picture. (BJP, February 1, 1864.)

Each morning after ten o'clock a fierce wind whipped through the river valley and hampered his operations. Any wind movement of trees or shrubs during long exposures would have disappointed him greatly: "On one occasion, I waited six days rather than leave two remarkably fine pictures or take them under unfavourable circumstances." (BJP, February 1, 1864.)

Bourne was eager to see more of the Himalayas and headed in a northwesterly direction toward the Taree Pass and an area called Spiti. His photographic work was going well, but one day he discovered that because of ill-fitted bottle stoppers, he had spilled some essential chemicals. Not having any distilled water with him, he might have had to cease his work, but he tested the water in the hills and found it purer than his distilled water had been. He mixed new baths and not only found they were superior to his old ones, but that they had "a peculiar aptitude for rendering clouds." Bourne's joy at being in such awesome surroundings is reflected in his narrative:

> What a mighty upheaving of mountains! What an endless vista of gigantic ranges and valleys, untold and unknown! Peak rose above peak, summit above summit, range above and beyond range, innumerable and boundless, until the mind refused to follow the eye in its attempt to comprehend the whole in one grand conception. . . . It was impossible to gaze on this tumultuous sea of mountains without being deeply affected with their terrible majesty and awful grandeur, without an elevation of the soul's capacities, and without silent uplifting of the heart to Him who formed such stupendous works . . . and it must be set down for the credit of photography that it teaches the mind to see the beauty and power of such scenes

as these, and renders it more susceptible of their sweet and elevating impressions. (BJP, February 15, 1864.)

After six days' march, the expedition arrived at the foot of the Taree Pass. A great debate was raging in Europe about the origin and movement of glacial masses, and Bourne was quite eager to have direct confrontation with the mysteries of the Taree Pass glacier. At 15,282 feet he was 400 feet higher than Mont Blanc in Switzerland, but he was amazed to realize that the peaks surrounding the pass were 4,000 to 7,000 feet higher. The glacier, about a mile in diameter, was covered with huge wave-like masses of snow and ice, and the wind howled constantly. Enormous rocks had fallen from above and lay scattered about.

Everything wore an air of the wildest solitude and the most profound desolation. . . . While at this elevation I was anxious, if possible, to try a picture; but to attempt it required all the courage and resolution I was possessed of. In the first place, having no water I had to make a fire on the glacier and melt some snow. In the next place, the hands of my assistants were so benumbed with cold that they could render me no service in erecting the tent, and my own were nearly as bad. These obstacles having at length been overcome, on going to fix the camera I was greatly disappointed after much trouble to find that half the sky had become obscured, and that a snow storm was fast approaching. Shivering through my whole frame and almost frozen to the ice, I stood waiting to see if it would blow over. It did so in about fifteen minutes, but not in the direction I wanted to take a view; but as there was no probability that waiting longer would better my condition, I placed the camera and proceeded to coat a plate. I thought the collodion would never set. I kept the plate at least five minutes before immersing in the bath, and even that was hardly long enough. Exposed fifteen seconds (size 12 x 10), and found it was somewhat overdone; but my hands were so devoid of feeling that I could not attempt another. I managed to get through all the operations, and the finished negative—though rather weak, and not so good a picture as it would have been if the snow storm had not prevented my taking the view intended—is still presentable, and I keep it as a memento of the circumstances under which it was taken, and as being, so far as I am aware, a photograph taken at the greatest altitude ever yet attempted. (BJP, February 15, 1864.)

On September 18, after crossing the pass, they made their camp, and the first major snow of the season began to fall. Suddenly, with a foot of fresh snow all around, all thirty of his coolies ran away, leaving Bourne with no way to continue with all his possessions. It would be at least three days before new bearers could arrive from the nearest village of Spiti, and to keep himself from freezing, Bourne spent most of that time lying in

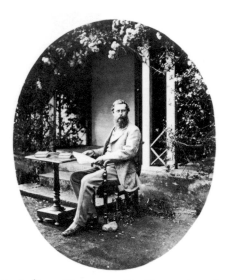

Figure 2. Portrait of Samuel Bourne, ca. 1864. Photographer unknown.

his tent. "All my enthusiasm in photography and my great desire to see the mysteries of nature at high altitudes would not have urged me to this undertaking had I known what awaited me in that miserable interval." (*BJP*, February 15, 1864.) On the fourth morning, new coolies arrived and Bourne lost no time leaving the glacier. The trail had been obliterated by the snowfall, and huge crevasses yawned on all sides, but the coolies from Spiti knew the Pass well. They finally arrived safely at the other side after spending nearly six hours up to their necks in snow.

They descended into the Wangu Valley, where Bourne's pleasure seems to have been in direct proportion to his difficulty and discomfort on the Taree Pass. He spent a week with good weather making many photographs of the steep, lofty mountains and deep ravines cut by the Wangu River. He then began his journey back to Simla. His chemical supplies were exhausted and he sought the company of Englishmen once again. The return trip was as trying as the outbound journey, and after several near tragedies, they caught sight of Simla on October 12, 1863. A broken ground glass was the only casualty of the ten-week journey, and he had made 147 negatives. Bourne felt that these negatives represented "scenery which has never been photographed before, and amongst the boldest and most striking on the face of the globe." (*BJP*, February 15, 1864.)

At the termination of this expedition, Bourne spent a five-month period photographing and traveling in the cities of central India—Lucknow, Delhi, Agra, Futtehpore Sikri (near Agra), Mussoorie, Lahore and Umritsur. The character of the photographs from this period is slightly different. These are architectural images greatly dominated by a single subject, usually a temple or a ruin. Each is quite clear and straightforward, and Bourne seems to have been cataloguing the unusual architecture rather than making the simply scenic views found

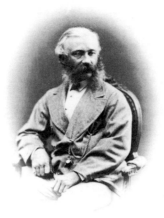

Figure 3. Charles Shepherd, ca. 1865. Photographer unknown.

in the expeditionary work. In each town he photographed the primary structures that would be of interest to his English audience. For the first time, Bourne used a 12 by 15-inch camera, the largest he used in India.

The photographs from this trip are among the first Bourne sold in great numbers to English tourists in India. In early 1864, he had gone into business in Simla with a partner named Howard, and along with these images of cities, a series of photographs made in and around Simla in 1863 were also sold under the name of Howard & Bourne. Shortly thereafter, a third member was added to the firm, Charles Shepherd.

This business arrangement gave Samuel Bourne commercial outlets and allowed him to make his subsequent journeys freely, while Shepherd, who was a fine printer as well as photographer, looked after the business. Toward the end of his second expedition, in late 1864, Bourne sent hundreds of exposed negative plates to Simla from Kashmir. By the time he arrived, many were printed and already mounted in albums.

BOURNE'S SECOND EXPEDITION was far more ambitious than his first, and required more extensive equipment. He had clearly learned much on his first trip and had realized, for instance, that the load that each man was expected to carry should be small and reasonably light. He prepared most of his baggage in that way.

My photographic requisites consisted of a pyramidal tent ten feet high by ten feet square at the base, very simple in construction, having merely a bamboo rod at each of the four corners, and opening and closing like an umbrella. This, though only one man's load, will seem a ponderous article when compared with the tents used in England;

but in this country I could not work in one of those little suffocating boxes without elbow room and without ventilation. I like to have plenty of both, as I am jealous of the bloom which I hitherto maintained on my cheeks, and of the hale and robust constitution with which nature has blessed me. My stock of glass consisted of 250 plates 12 x 10, and 400 plates 8 x 4½. . . . In all, my photographic requisites formed about twenty loads; the remainder consisted of personal baggage, tents, bedding, batterie de cuisine, hermetically-sealed stores, a good supply of Hennessy's brandy, in lieu of "Bass" and "Allsopp," sporting requisites, books, camp furniture, etc., etc. When starting on a ten or twelve months' journey like this it is advisable to take as many portable luxuries as possible (as I afterward found), seeing that I was for two months in some solitary and remote district without ever seeing a European, talking nothing and listening to nothing the whole time but barbarous Hindustani and a hundred local compounds of the same. When everything was packed and ready I found that I should require forty-two coolies!—quite a little army in themselves. In addition to these was my staff of servants and six "dandy" bearers. ("Narrative of a Photographic Trip to Kashmire [Cashmere] and Adjacent Districts," *BJP*, October 5, 1866.)

After dispatching his army by bullock cart ten days earlier, Bourne left Lahore on March 17, 1864 for Kangra, a small town 140 miles to the east, where he expected to begin photographing. Kangra, on the border of a beautiful valley full of tea plantations, is widely known for its fertility and verdant loveliness. This valley borders the outer range of the Himalayas. Bourne's first photographs from this trip were of the fine old fort at Kangra.

The expedition continued on to Byjnath, where Bourne's description of an encounter with a Buddhist priest illustrates his continuing intolerance toward the Indians.

I observed that preparations were being made for the morning religious ceremony. I was not permitted to go inside, but could see a hideous wooden monster in a little dark chamber at the further end, and an older man, who, I suppose, was a high priest, in the act of presenting this sublime deity with his morning repast. This consisted of some compound of "ghee" (clarified butter), sweetmeats, and chupatties, not a particularly tempting dish for beings of less dignity than gods. This having been set before his august majesty the little door of his chamber was closed, and immediately there was set up a hideous clamour of bells and drums and tinkling of pot lids, or something very much like them, till the god was supposed to have partaken of sufficient of his delicious food. The priest then reopened the door, and, after bowing very low

to the god, brought out the untouched food, which was forthwith carried to his own house, where I doubt not it would meet with a different fate. When the ceremony was over I ventured to intimate to the priest that the god had apparently not liked his food, as he had not touched it. He replied that he had eaten a little of it, but, that being a god, he did not want a great deal. I then tried to show him the absurdity of all his devotions; that his god was a senseless block which could neither eat, drink, speak, or render him any assistance; that there was but one God in the wide universe, which was so unlike his own, and so unlike the race of men, that we could not see Him; that He wanted no food, but lived for ever in the heavens, and required all men to worship Him. He listened attentively, and said that He might be a very good sort of God in His way but was inferior to his own, so I left him only more confirmed in the grossness of his own belief. (BJP, October 5, 1866.)

With forty-two coolies under his control, Bourne had his hands full. To make matters more painful, these coolies had to be replaced at each stage of the journey. He would send a servant ahead two or three days in advance and arrange with a village *lumbadar* to have new coolies at the ready when the party arrived. At one village he found that fifty new coolies who had been impressed into service were crammed into a loft, the ladder removed to prevent escape. Two miles out of town the next morning, Bourne came upon two boxes left unattended on the roadside, their carriers having fled. He was forced to wait by these boxes while a servant went to fetch new carriers, a task requiring several hours. He had not gone a quarter of a mile further when he came upon another load, and then yet another.

This was getting serious, and I vowed vengeance against the rascals who had placed me in this difficulty. I was told that these men had no doubt hidden themselves in a village which I saw at a little distance from the road. Taking a stout stick in my hand I set out in search of them, in a mood not the most amiable. After searching several houses unsuccessfully, my attention was attracted to another, where two women stood at the door watching my proceedings. I fancied they looked guilty, and at once charged them with concealing my coolies. "Nay sahib; koee admee nahe hy mera ghur pur; coolie nahe hy." (No sir; there is no man in my house; there is no coolie.) Not satisfied with this answer I walked in, and soon discovered my friends hiding beneath a charpoy or bed, and dragging them forth made them feel the "quality" of my stock, amid the cries and lamentations of the aforesaid females. (BJP, October 19, 1866.)

After several days, the trail led to Chumba, a picturesque mountain village surrounded by grassy slopes 1,500 feet above the rushing Ravee River. Bourne counted no less than fifty Hindu temples there. The day after his arrival, Bourne was visited by the Rajah of Chumba, who, as it happened, was a photographic enthusiast far more interested in looking at cameras than looking through them. When Bourne returned the visit on the next day, the Rajah primarily wanted to compare cameras, lenses, chemicals, telescopes, watches and chains. Bourne was amused "to see the simplicity and childishness which he manifested in everything, and how glitter and outward show were held in his estimation superior to real qualities and intrinsic worth." (*BJP*, November 2, 1866.) Following a rough map, the expedition left on June 8, 1864, for a direct march to Kashmir. Crossing rude rope bridges over rushing rivers, and even using inflated mussuck skins as flotation devices to carry the great cargoes across other streams, Samuel Bourne headed north.

Though the scenery was lovely, Bourne felt that the Swiss Alps, as seen in the Bisson Frères' or William England's work, were more pleasing and picturesque than anything he had so far seen in the Himalayas. As he began to come to grips with the unimaginable immensity of the Himalayas, though, he experienced great self-doubt, feeling that the painter was better suited to deal with this scale and distance. The photographer could, he felt, deal only with "bits" and small distances, whereas the painter could convey much more of the idea of the place, giving to people at home "some idea of what the Himalayas are really like, which we of the camera can hardly do." (*BJP*, November 23, 1866.) Bourne's solitude gave him opportunity to reflect.

Here was I, a solitary lonely wanderer, going Heaven knew where, surrounded by the gloomy solitude of interminable mountains which seemed, in fact, to stretch to infinity on every hand. To attempt to grasp or comprehend their extent was impossible, and the aching mind could only retire into itself, feeling but an atom in the world so mighty, yet consoling itself with the thought that the Power which formed these ponderous masses was greater than they, and that in the marvellous and benevolent operations of that Power, itself, however humble and insignificant, was not lost sight of. (BJP, November 23, 1866.)

Wandering through India with great feelings of superiority to the Indians and their culture, carrying a camera for capturing the "truth," Bourne understood, in a lucid moment on a mountain pass while contemplating the vastness, that his delicate and specific grasp of reality, his analytical photographic vision, his logical and rational Victorian mind, his religious constructs and his enormous sense of rightness were all lost in that immensity. This reality easily overpowered his cultural understanding. The fact that he couldn't record it, couldn't capture and subjugate it all to his will, depressed him. It was not even possible to bring the insight of that fact to his photographic plate.

Expeditionary photographers like Bourne not only used the camera to collect information, but also to establish a certain kind of control over the land; to impose a visual order on the chaotic landscape, and to shrink by the medium's own abstract logic the expanse of the world to a small print that could be handed over the table in polite drawing rooms in London for all to witness the superior ordering of God's rational creation. But in this experience on the pass, the void stared back at him and Bourne realized the narrow confinement of culture and photographic potential. On that mountain top in India, cracks started to form in Bourne's concept of photography, in his sense of reality, in his world view. Finally, thousands of miles from home, months away from European influences, Bourne really began to see.

The Chenab is one of the five rivers of the Punjab. It was through the Chenab Valley that they now pushed, and on toward Kistawar, Singapore and the Meribul Pass. From the top of the pass, Bourne caught his first view of "The Vale of Kashmir." After an hour contemplating what he called "this sublime panorama," Bourne began his descent down the snowy slopes by sliding forty to fifty yards at a time. The coolies had to struggle down as best they could. After two hours, a servant arrived at the bottom, where Bourne had been waiting. "Sahib," said he, pulling a long face, "one box has fallen down." "For heaven's sake! what box?" "The large box of glass, Sahib, and it is all broken." (BJP, December 28, 1866.) Fortunately, the plates broken were unexposed 10 by 12-inch plates, and Bourne was able to salvage a number of the damaged pieces by cutting them down for his 8 x 4½ camera. This box had been the only one too large to be carried by one man. Two bearers had fastened it to a bamboo pole for ease of carrying, but had discarded the pole in the descent from Meribul Pass. One man had taken the box on his shoulders, while the other pulled on a rope attached to the box from behind and acted as a brake.

> This was of course a most absurd arrangement, for when the first man slipped, which with such a weight he was almost sure to do, the second was powerless, and so the box rolled down a declivity about a thousand feet. The men were carried with it for a considerable distance, causing one a broken arm, and the other the fracture of one or two ribs. (BJP, December 28, 1866.)

Bourne had some thirty-six plates left, and Simla, a month away, was the nearest place to procure more glass. To compound his problems, he now discovered a cracking in the emulsions of five or six of his finest negatives. The cracking was probably caused by successive condensation and drying while the negatives were carried through vast changes in temperature and humidity. By interleaving the plates with blotting paper, Bourne found he was able to stop further damage.

The trek progressed through Kashmir, past Waugand, Vernag and Achabul to the ruins of Martund. Wild roses and leafy bush creepers were blooming profusely, but the weather was searingly hot. They went on to Islamabad, where the entire party boarded river boats for a gentle and lazy two-day float to Srinagar. They arrived around the 3rd of July, and if it was the picturesque that Bourne sought, Srinagar could not disappoint him. Laced with bridges and canals, and built on a lovely lake, Srinagar was also the site of the Garden of Shalimar, the Garden of the Morning Breeze (Nasib Bagh) and the Garden of Pleasure (Nishat Bagh), each a lovely park of cool shade and fruit trees.

Srinagar was a delight for Bourne. He averaged five or six photographs per day and he toured the town, the lake and its islands on a private boat. The pictures seemed to compose themselves.

> Photography here became one of the most delightful occupations. The only difficulty I had generally to contend with was the obstinacy of the natives when I wanted to introduce them into my pictures. By no amount of talking or acting could I get them to stand or sit in an easy, natural attitude. Their idea of giving life to a picture was to stand bolt upright, with their arms down as stiff as pokers, their chin turned up as if they were standing to have their throats cut; the consequence was that I had often to leave them out when I should otherwise have introduced them. (BJP, January 25, 1867.)

After ten very pleasurable weeks, on September 15, 1864, Bourne left Srinagar. Aiming north toward the Scinde River Valley, he spent a few days on Manus Bul, a lovely little sparsely-populated lake area, now an Indian resort. Three more days were spent marching toward the far end of the Scinde River Valley. The first two days held little interest, but the third day introduced him to some of the finest scenery he had ever encountered.

> For about six miles it was one constant succession of pictures—one scene of absorbing beauty. Rocks, woods, water, mountains, precipices and snow mingled in happiest combination—beauty and strength, softness and grandeur, peace and terror vied with each other in displaying their charms to the utmost. Where, thought I, shall I begin, and where shall I end my operations here? (BJP, January 25, 1867.)

He lost track of all time in making numerous exposures. His servants had gone on three miles up the valley to set up camp, but Bourne kept working. As night rapidly fell in the shadows of the mountains, he slowly and carefully crept on an uncertain track to his camp. He became aware of the freezing cold, and began to fear that he would never find his way. Soon it was absolutely dark and he couldn't see his path at all. He risked freezing if he stood still; by moving on he risked becoming lost, or worse, falling over some precipice. As fear became terror, he saw a light in the far distance that seemed, upon examination, to be approaching. His servants were looking for

him with lanterns. A hot dinner and a large fire awaited his return, and he resolved never to put himself in such a position again.

> *When I awoke the next morning the thermometer stood at 22° below freezing point, and my unfortunate coolies, who had to 'sleep the sleep of the weary' on the cold, cold ground, stood shivering round the embers of last night's fire, wondering no doubt what could induce the 'sahib' to wander into regions like these.*
>
> (*BJP*, February 8, 1867.)

After trekking another eight miles up the valley and climbing a twelve thousand foot pass to obtain two negatives, they were all eager to retrace their steps to a warmer climate.

A near disaster occurred on one of Bourne's last days in the Scinde Valley. Attempting a photograph, he pitched his dark tent on a narrow path on a mountain top. There was insufficient width to extend it fully, and he crouched inside for fear of falling three hundred feet to the river below. While developing a plate, he was informed that a caravan of twelve fully loaded ponies desired to pass and that his tent blocked their only route. He kept them waiting for quite a while, and the men of the caravan grew impatient. Finally allowing them to transverse the slope just slightly above the tent, he watched as perhaps half of them passed, then went back inside to develop another plate. As the last animal passed, it lost its balance and fell on the dark tent and Bourne. Bottles, measures, chemicals—all were smashed, and Bourne nearly went over the edge. He freed himself in time to watch the pony walk off uninjured. By improvising with empty brandy bottles, he was still able to work, and the expedition continued out of the valley.

Passing by boat through Manus Bul, Wulur Lake, Sopur, and the Jehlum River to Baramula, Bourne seemed uninterested in photographing, making only two photographs in nine days of travel. After several days at the Hill Station of Murree he exposed nine plates, and made a brief stop in Rawne Pindu (Rawal-pindi). In Sealkoto (Sialkot) he made, at the request of two gentlemen he met in Kashmir, photographs of a group of British officers and their regiments. These images were added to a group of at least 95 regimental photographs, most made by Shepherd, and were listed in the Bourne and Shepherd catalogues along with many group portraits such as those of Moravian missionaries at Lahore (1864) and curators of the Agra exhibition (1861).

Bourne had received a letter from friends who lived in Lucknow inviting him to a Christmas celebration, but by December 16 he still had nine hundred miles to go. For seven days he rode on rough dirt roads in a *dak gharry*, a crude horse or bullock drawn conveyance. The last three hundred miles were finished in the comfort of a railroad coach. About 6 o'clock the evening of December 24th, he arrived in Lucknow for a Christmas feast and a celebration in his honor after ten months of travel. One of his first activities was to examine the albums that contained five hundred or so prints made from negatives he had sent from Kashmir. For a series of ten of these images he was awarded the Bengal Photographic Society gold medal in 1865; he received its silver medal for the best single picture.

Between late December of 1864 and late June of 1866, Bourne traveled extensively and photographed in the area southeast of Delhi going as far as Benares. There is no written record of these travels, but we can create a rough chronology from his numerical cataloguing of the 425 pictures he made during this time. In the six hundred miles between Benares and Simla, Bourne photographed at such places as Gwalior, Allahabad, Agra, Futtypore Sikri, Subathoo, and Deig. In all of these areas he photographed architecture as well as scenes of interest relating to the 1857 war. Some of his finest studies of Indian temples and mosques were made on this trip. His photographs of the Motee Musjid (PLATE 1) in Agra, the Ancient Brahminical Temple in the Fort at Gwalior (COVER), and the Great Mosque of Arungzebe and adjoining Ghats (PLATE 5) show his extraordinary diversity of composition and his flexibility in handling an extremely broad range of lighting conditions.

The photograph of the Temple in Gwalior is a romantic image that appealed to Bourne's sense of the picturesque. The decaying grandeur of this temple illustrates the power of natural forces to tear down what man has built. The sun seems to dissolve the edges of the structure while in the center of the building dark shadows remain, holding mysteries. The stairway on the right allows the viewer a point of entry, and a small road, also on the right, leads to the back of the temple and perhaps to the vague shape of yet another structure on the horizon. In this image, Bourne shows India as a land of past glory, filled with monuments pointing back in time.

The Purana Kila, Old Fort of Delhi, is a much more abstract statement for Bourne, and once again space and dry, infertile earth dwarf man's creation. This old fort is no doubt an imposing structure of massive scale, but Bourne recognized the far greater magnitude of the forces that have defeated it. In his picture the fort becomes a strip of detail in the middle of the frame, forming a horizon line of broken towers and battlements. The fort seems to be sinking back into the earth from which it was made. The enormous foreground of gravel, dirt and a patch of rough grass dominates this photograph; a thin wisp of a trail materializes in the front and wanders in a curving line to the fort, pointing to two tiny figures conversing in the middle. Several trees scattered around are almost indistinguishable from shadows cast by the piles of the fort's fallen rubble. This composition, quite acceptable in the 1980s, would have been thoroughly inappropriate in the Victorian era without the literal notion of the fort's decay by the forces of nature, and there is no doubt that Bourne saw it that way.

As Bourne traveled, he also arranged his notes from his trek to Kashmir; by June 27, 1866, he had written a long letter to the *British Journal of Photography* that was published in the winter of 1866-67. Bourne's images were also on display in England during this period, and they received high artistic praise in the periodical.

> *How, traveling through such sultry scenes, oppressed betimes with heat, wind and dust, Mr. Bourne has managed to secure such faultless pictures we cannot imagine; for there is not a speck or spot to disfigure them, not a trace of fog, no fracture of the collodion even at the corners, no pinholes, and, in brief, none of those technical shortcomings so commonly met with in the production of all save a few of our best home artists. And yet these views were taken under circumstances of which few can form an adequate idea.* ("Our Editorial Table: Interim Photographs by S. Bourne," *BJP*, January 11, 1867.)

ON JULY 3, 1866, Samuel Bourne again departed Simla to explore the "rich valley of the Beas River through Kulu, penetrate into the wild and desolate regions of Spiti as far as the borders of Thibet, thence via Chini and the Buspa Valley, to the source of the Ganges." (*BJP*, November 26, 1869.) His chronicle to the *British Journal of Photography*, titled "A Photographic Journey Through the Higher Himalayas," was written about two years after he returned from the expedition, from notes made while en route, and was published in 1869.

> *In the first place, I make no pretensions to scientific travels —my object was purely pictorial. . . . Therefore, my narrative will be found to be made up of much egotism and allusion to self; while from all 'geographical, geological and botanical research, from all sound learning and religious knowledge, from all historical and scientific illustrations, from all useful statistics, from all political disquisitions, and from all good moral reflections,' it will be found to be eminently free.*
> (*BJP*, November 26, 1869.)

The narrative, however, is full of interesting, useful, geographical information, great adventure and plenty of moral judgment, if not reflection.

There was clearly a commercial purpose served here. Bourne had long since printed and catalogued his photographs from this third expedition. It is possible to read through this narrative with either the 1867 or 1870 photographic catalogue of Bourne & Shepherd in hand and follow, paragraph by paragraph, plate by plate, the progress of this journey. The chronology is unbroken throughout the entire expedition, and the article serves as an advertisement for the photographs, which were, by the time the narrative appeared, available to the public. In fact, the final sentence in the letter is, "In bidding adieu to my readers, I will only add, in conclusion, that if any of them who may have felt an interest in following me through my long trip would like to see the views I took, the results of many a hard day's work, and hundreds of miles of rough traveling, they can do so by applying to Messrs. Marion and Co., of Soho Square, who are the agents for their publication in England." (*BJP*, April 1, 1870.)

Shortly before the commencement of this third major expedition, Samuel Bourne was approached by a man with whom he was slightly acquainted, who asked if Bourne might allow him to travel along as a companion. Dr. G. R. Playfair, who had been living in Agra, was originally from Scotland, where his brother, Dr. Lyon Playfair, was a Member of Parliament. Dr. Playfair was able to add a good deal of botanical and geological information to the journey, as well as to offer companionship to Bourne, who never looked forward to being surrounded only by speakers of Hindustani.

This trip began with sixty coolies from the rough mountains near Ladakh. They were hired for the entire journey, thus solving major problems of hiring porters at each town and reducing the risk of defections. After four days of travel along the Tibet road, under southwest monsoon rains, they reached Narkunda, where Bourne made his first picture of the journey. Descending three thousand feet to the Sutlej River, they continued over rugged terrain. Passing the towns of Kot and Russala, the rain continued, making the coolies' loads heavier. They crossed the Jalori Pass to Mungalor, where the heat drove the dark tent temperatures to 130°. The next day, they arrived at the Beas River.

> *Presently we had to cross the river, which was here about eighty yards wide, by means of "mussucks," or inflated buffalo skins. . . . All our coolies and baggage had to be brought across by the same means. This occupied about three hours. . . . While this was going on I grouped a number of the mussuckmen with their skins on the river bank and took a photograph of them, which to those unacquainted with this mode of crossing rivers looks a most mysterious picture* (PLATE 7).
> (*BJP*, December 3, 1869.)

After spending an evening with some local Britons in the village of Nagar, Bourne reported,

> *When preparing to start the next morning I found a mutiny amongst my coolies. Hitherto they had had a good road and comparatively easy work, but now that we were approaching the snows, and finding that we were going to cross one of these high passes, they did not like the prospect, and some eight or ten of them feigned illness or made some excuse or other and expressed a wish to return . . . they were very resolute and stubborn, and declared they would not go, while two or three of them showed a*

disposition to bolt. On seeing this I took a handy stick, and laid it smartly about the shoulders of several of them till they lay whining on the ground. I gave them little time for this luxury, but made them buckle to their loads in double quick time. This bit of seasonable sovereignty had a good effect, as I never afterward had the least trouble with these men. (BJP, December 17, 1869.)

The expedition continued eastward, climbing toward the Hampta Pass. On a frosty morning, Dr. Playfair and the majority of the porters began to cross the pass. Bourne stayed behind to make a picture or two, but was delayed by a recurrent mist that shrouded the scene. After finishing his work, he set out in pursuit of the party, and was soon in a very rough area with no track to follow. After several hours, he lost all sign of his group.

I felt like the remnant of a shipwrecked crew who have been tossing on the waves for many days in a small boat, and see the ship which they fondly hoped would come to their rescue departing without having perceived their signal of distress.

Finally, after he had wandered for several hours in a near panic, the coolies heard his call and waited to escort him to camp on the other side of the pass. Having lost his sense of humor, he accosted his friend Dr. Playfair, showering him with complaints that didn't end until dinner and brandy had arrived. After this difficult and frightening event, Bourne returned the next two days to photograph in the very terrain of his previous day's adventure, taking pride that he would go back to work where he had scarcely survived.

Ah! you gentlemen! and you, careless public! who think that landscape photography is a pleasant and easy task—a sort of holiday pastime—look at me toiling up that steep ascent in the grey dawn of a cold morning in fear and trembling that my labour would be all in vain! See me sitting for ten mortal hours, shivering in cold and mist, on the top of that bleak pass, waiting for a 'break,' which would not come! See me descending, disappointed, at night to my tent, to return next day and go through the same again, and say if this is pleasant pastime! (BJP, December 24, 1869.)

The descent from the pass to the Chandra River was quick, and the intense heat of the river valley was followed later by more ice as they crossed the great Shigri Glacier. The expedition moved through exotic landscape—across the Kunzan Pass at 14,931 feet, through Losar along the Spiti River to Kiota, past curious rock and fossil formations. Bourne made some superb photographs of enduring power, while Dr. Playfair collected rare and beautiful fossil shells at the 15,000 foot level. They passed Kibber and arrived at the Monastery at Ki, which Bourne recorded with a brilliant image wherein the monastery, consisting of numerous box-like, whitewashed rooms clustered together, is perched on top of a conical hill of rough rock and gravel, surrounded by parched, rugged mountains void of greenery (PLATE 9). The Monastery sits, baking in the intense sun, directly in the center of the image and is somehow illuminated by a shaft of brighter light. The simplicity of the vision helps to focus on the absolutely inhospitable environment in which the Buddhist priests chose to live. The rolling horizon line, and the undulating striations in the rock faces have a wave-like grace; the Monastery balances like foam on a large breaker.

Bourne then set out for the Manirung Pass, toward the epitome of all of his photographic quests. Crossing the very crude Jhula Bridge over the Spiti River, and then stopping to photograph it, Bourne continued on to the village of Mani for which the great pass is named. In these barren lands, where food was not easily grown or purchased and where few travelers visited, the arrival of a large procession of hungry coolies was not often welcome. Not only did this entourage have to be accommodated, but they also needed sufficient goods for the next stage of their journey.

When the natives of Mani became aware that it was my intention to cross the Pass they besieged me in numbers, and endeavored to dissuade me from the attempt. Every argument which they thought would be likely to tell they brought to bear. They said that it was three years since any "sahib" had crossed it (which was not true); that but very few had ever crossed it at all; that it was not only a very steep and difficult ascent and descent, but that in many places it was also very dangerous, especially in bad weather, as it was likely to be now; that the stones and rocks above got loosened by the frost and rain and were perpetually falling down, frequently killing their own people whenever they had occasion to cross over; and that in addition to all these difficulties, the small-pox was at that moment raging in the villages through which I must pass on the other side. (BJP, January 14, 1870.)

Pausing for a time to think over his next move, Bourne considered his responsibility to his team and to his equipment, as well as to the very valuable negatives he had previously made. He assumed that the villagers were exaggerating, because of their reluctance to supply the necessary goods and to serve as guides, or as porters for the extra supplies; their fear of small-pox was so great that bridges to infected areas had sometimes been destroyed.

Calling some of the head men of the village, I told them that all their arguments were in vain; . . . that they must forthwith bring sufficient provisions for all my men for five days; that I wanted several sheep for my own eating and to give the coolies, if necessary; and that a number of them must accompany me over the Pass to act as guides, and to assist in carrying the extra provisions; and finally, that all must be ready to start at five o'clock next morning.

. . . When daylight dawned next morning I was astonished to see half the village collected round my tent, with bags of flour, a whole drove of sheep and goats, a yak for me to ride on, two or three ponies for my servants, and a number of men equipped for the journey.
(*BJP*, January 14, 1870.)

At least eighty people, plus animals and cargo, slowly moved toward the Manirung Pass. By four o'clock in the afternoon they had reached the foot of the pass at an elevation of seventeen thousand feet, where they made camp for the night. The next morning found the pass shrouded in very dark, rumbling thunder clouds. At the advice of the guides, no attempt was made to proceed that day; in frustration they waited in camp for a clearer morning. Before dawn the next morning, a very anxious Samuel Bourne watched the ever lightening eastern sky with growing excitement. Not a cloud appeared. While the stars were still quite visible, they prepared to depart for the top of the pass in search of photographs.

By 8:30 a.m., Bourne stood at 18,600 feet above sea level, on the crest of the Manirung Pass. Searching for adequate words to describe this moment, Bourne wrote:

But how shall I describe such a situation, or convey to the reader any idea of the wondrous extent of view which spread around me? From my very feet rose the Manirung Peak, 3,000 feet still higher, forming the northern boundary of the Pass. Across the glacier on the opposite side was a somewhat lower range, presenting a singular contorted structure in those parts not covered with snow. Looking toward the east and south, a mighty succession of snowy ranges stretched beyond the limit of vision into the vast unexplored regions of Thibet, and beyond the sources of the Ganges and Jumna to the sacred shrines of Redarnath and Budrinath. . . . I seemed to stand on a level with the highest of these innumerable peaks, and as the eye wandered from range to range and from summit to summit, all robed in the silent whiteness of eternal winter, it seemed as though I stood on a solitary island in the middle of some vast polar ocean, whose rolling waves and billows, crested with foam, had been suddenly seized in their mad career by some omnipotent power and commanded to perpetual rest. All was still and serene.
(*BJP*, January 28, 1870.)

Bourne quickly set to the task of recording this awesome scene, but in his excitement he had greatly outdistanced many of the coolies; much of his necessary photographic equipment lagged far behind. He sent some of the faster coolies who had already arrived back to help the slower ones. Their progress was tedious over the rough glacier, and it was not until eleven o'clock that he was able to begin.

In previous moments of inspirational rapture, Bourne had been unable to comprehend the awesome majesty of this environment through contemplation of its vastness, and this had always led to the frustrated feeling that photography was insufficient to the task of recording the totality of the visual and visceral experience. Now, at the top of this immensely stunning Himalayan pass, and after months of dealing with this obstacle, he seemed to break through. In his written account he never mentioned the frustration, and evidenced no philosophical blockages. He simply leaped into action and began to make very specific and elegant images, realizing that the entire scope of his knowledge and awareness would not be visible from any one spot. The three photographs that he made before the clouds rolled in to obscure everything are some of the starkest, most eloquent images in the history of photography. They are emblematic of all expeditionary photography.

With brilliant skill, the artist placed seven bearers in the lower right (PLATE 15) and a bare wedge of earth in the lower left, thus adding scale and a grounded perspective without which the mountains would seem to float weightless and with indistinct mass and size over the glacier. The mountains themselves are wave-like, particularly the one on the left. The shape and striations of its graceful upbearing could have been created by a single stroke from a Japanese master's brush. The loaded coolies stand patiently and calmly, waiting for the photographer in the midst of a nature terrible and wild, omnipotent beyond all human comprehension. Unaware of this tiny invasion, nature's forces work too slowly to be seen in a photograph, but the grace of the striations in the mountains show how the rock grew from the earth and give a sense of animation to the mountain that equals that of the humans.

On approaching the coolies with orders to prepare for the descent, Bourne found some sprawled on the glacier.

. . . groaning piteously, and complaining of pain in their temples. I felt the same to some extent myself, but not nearly so much as they apparently. I told them to get up and begin the descent, when they would feel better; but they lay and groaned on still, said they did not want to get up, but would lie there and die.
(*BJP*, January 28, 1870.)

Believing this to be true, he physically forced each man to his feet and saw them on their way. The descent was steeper and rougher by far than the ascent had been, nearly a mile of sheer ice and rock down to the valley. The path was so rough that Bourne was not able to ride his yak. Eventually the bottom was reached and they camped at the foot of an enormous glacier, where Bourne photographed the desolate, contorted rock strata and ice.

They had not gone much further the next morning when the valley in which they traveled contracted into a narrow gorge with two thousand foot perpendicular walls. Only the river passed through it; there was no trail. Pondering their next move, they camped for the night. Bourne wanted to photo-

graph here, but there was no room on the tiny trail to set up his equipment. In the morning, it appeared certain that the only direction possible was a retreat along the path, back toward the pass; the high rock walls imprisoned them everywhere else. Bourne finally consulted the village guide, who pointed far up the left side of the cliff face. With the aid of a glass, Bourne could see vague traces of a path high above the rushing river.

> *I shuddered as I surveyed the nature of this perilous track, and plainly saw that, dangerous as the Manirung Pass had been, it was safety itself compared to this. . . . I stared, not without fear for the loss of some of my material, if I did not come to grief myself. . . . One false step, one little slip, and I should have found myself in the stream and in eternity the next moment. I dare not look down in such places, but, my face to the rock, held on to the hand of my attendant who, being without shoes, could secure a firmer footing. How my coolies with their heavy loads, some of them unwieldy things like tent-poles, ever contrived to get safely over this five miles of walking on a ledge, instant death staring them in the face at every step, remains a profound mystery to me at this day. But get over it they certainly did; for when muster was called at night they were "all there" absurdly safe and sound, thus depriving my narrative of the interest it would have possessed could I have reported one or more of them dashed to pieces! (BJP, February 18, 1870.)*

Safely through the worst areas, they were now rewarded with a pleasant valley filled with ripe fruit trees. In the nearby villages the small-pox had run its course and its threat was nearly gone, but in the tiny village of Sungnam, three hundred people died of the disease.

Once again, the curious caravan moved on. They were forced to spend two days constructing a rope bridge by which to cross the Sutlej at the village of Barung. They now crossed a large mountain range to get to the Buspa Valley and the town of Sungla. The beauty of this forested valley soothed Bourne after three days, during which he made numerous views. After nearly fifty miles, they slowly came upon the glorious mountains and glaciers of the Neela Pass.

Rising to the pass, the drama of the view increased. Peaks and glaciers rose in each direction. The Buspa River has its source in the ice caves at the foot of an immense glacier that fills the entire valley. This glacier, hundreds of feet thick, and ten or fiften miles long, was Bourne's subject for three images. As he skirted the glacier and began his ascent to the pass, he became enchanted by scenes of ice and snow which, because clouds and mist were presently obscuring his view, would be easier to photograph the next day. They made their camp on the glacier that night, at 14,000 feet, with no shelter from the freezing winds. Yet another day was required to make the photographs Bourne sought. "I think photographic enthusiasm could not go much further than this." (BJP, March 4, 1870.)

At this point a major disaster was revealed. The head man responsible for the coolies had been charged with the task of obtaining eight days of supplies at Sungla, but had instead purchased only enough for four days. They now had only one day's rations left with four days of marching ahead.

> *This was a horrible predicament and a serious one. I at once dispatched this wretch back to Sungla with orders to procure more 'atta' (flour) and bring it on without a moment's delay, but we did not see him again for five weeks. Half fed, scantily clad and having to lie down for two nights on the freezing ice without even the shelter of a rock, was indeed a pitiable situation for the poor coolies. I gave them the last three sheep I had, and dispatched two men forward to the next village; but before they returned with the 'needful' the men had been two days without food, and were becoming desperate. . . . Had not relief come when it did . . . they would probably have 'done' for me, as the author of their misery.*

(BJP, March 4, 1870.)

The wait for help was made more difficult because the weather did not clear. The photographs Bourne made did not please him as much as they might have under clear skies, but he was deeply moved by the scene. "How small and frail a thing seemed man when placed in juxtaposition with these mighty mountains!" (BJP, March 4, 1870.)

After relief supplies arrived, they descended to the valley and stream bank on grassy slopes fringed with vines and creepers. At the end of one more day's pleasant travel, they arrived at the town of Mokba on the holy Ganges river, which at this point is a gentle stream. Carrying only light equipment, Bourne set toward the source of the river, twelve miles away. He followed rock-strewn chasms and rough paths and crossed the violent river over rope bridges. In some places, rude scaffolding and ladders leaned on the rocks to provide travelers with a firmer footing. They finally came to the sacred shrine of Gargootri, a small rustic temple visited annually by thousands of Hindus. Bourne wondered what was there to attract pilgrims from all over India to such a desolate spot, but it is the river, of course, and not the temple, that is holy. This site was three miles from the source of the river, and though Gargootri was close enough for some Hindus, Bourne insisted on going all the way. There was no trail, and the terrain was very rough. The holy Ganges flows as a turbulent flood from the ice cave at the foot of a major glacier. Bourne's were the first photographs ever made of Golmuk, or "Mouth of the Cow," the holiest spot in the Hindu religion (PLATE 17). This was one of the major objects of his expedition.

> *I felt a degree of satisfied curiosity, and that I ought to consider myself a privileged mortal in being permitted to*

gaze on this the first visible issue of the mighty and holy Ganges from the vast ice beds which cradle its birth. (*BJP*, March 18, 1870.)

Bourne made several images around the Gangootri Glacier and the 22,621 foot Mt. Moira that are superbly transcendent in their forms and balances. The mountain itself is seen as a dramatic and imposing pyramid of rock isolated and framed by surrounding rises on both edges of the picture that cause a bowl-shaped depression in the center of the image which perfectly cradles the massive triangular shape (PLATE 10). Huge boulders are strewn randomly over the foreground. Two figures are placed centrally for scale, and the realization of their size is almost baffling. A triangular shadow in the middle of the foreground predicts the pyramidal domination of Mt. Moira in the rear. The mountain, which is light in tonality, hovers almost ethereally above its earthbound audience. The confrontation of these microscopic humans with an archetypal mountain, can be seen as the ultimate metaphor for Bourne. It is in images such as this that Bourne's power completely transcends the "picturesque" aesthetic of his Victorian tradition. Far beyond the cultural confines that determine aesthetic attitudes, he saw and composed from his own comprehension. The results, while in the language of Victorian consciousness, are purely his own.

Finally leaving the Ganges Valley, they aimed for Jumnootru, since Bourne was interested in seeing the source of the Jumna River. At the village of Agora, Bourne sought information about the sacred lake called Dodee Tal. The natives did not appreciate European visitors and feigned ignorance about the lake. When he persisted, an old man finally stepped forward, saying the lake was twelve very difficult miles above the town. There was no road, and the lake was surrounded for miles by impenetrable and steep jungle, but he would escort Bourne, if required, though he sincerely suggested that it was not wise. Bourne accepted, assuming that it was only local exaggeration to keep him from visiting a holy spot. He soon repented not taking the old man's advice. Two men in the lead hacked at the jungle growth; noxious weeds, dampness and a suspicion that snakes lived there haunted them. When they finally arrived at the lake it was an isolated but disappointingly common one. He discovered the name of an English officer carved into a tree with the date 1831, but little else marked the lake as exceptional.

The next day they climbed an icy pass on the way to the source of the Jumna. As they descended the pass, a bearer slipped and fell, breaking a bottle containing the silver solution. Bourne had no replacement, so his photographic pursuits were ended. He could only press on to Mussoorie, the nearest sizeable hill station, seven days away, and wait for new chemicals from Simla. There he met old friends, and after his supplies arrived, he was soon photographing the town. They proceeded

again toward the Ganges and met it at the Hardwar. They moved on to Roorka and the Ganges Canal, to Murat and Moredabad, and then to Nanital, a lovely hill station with a lake surrounded closely by mountains. In all these towns he made dozens of photographs. Nanital was the last scene of his operations. Having completed his work, he returned by *dak gharry* to Simla via Meerut and Delhi. He had been gone six months, and as on his second Himalayan trip, he arrived just in time for Christmas, returning with a total of 229 images.

IN EARLY 1867, Bourne made a brief visit to England. On May 9th he married Mary Tolley, oldest daughter of silk merchant and elastic web manufacturer Abraham Tolley, at the George Street Baptist Chapel in Nottingham. Soon after the wedding, Bourne and his twenty-three-year-old wife returned to India. Together, they opened a second branch of Bourne and Shepherd in Calcutta; the nearly insatiable demand for photographs both in England and in India assured the success of the business. For a time, the young couple remained in Calcutta, where Bourne photographed the city extensively, making scenes of cathedrals, Hindu temples, the port area, Government House and even a seven plate panorama of Calcutta from the Ochterlony Monument. The 1870 Bourne and Shepherd catalogue offered fifty-two images made in Calcutta during this period, priced at four rupees each.

In autumn, the Bournes returned to Simla. By then the Viceroy and his entourage had returned to Delhi to run the country, and the hill station would have been quiet and peaceful. During the next several months Bourne completed a series of thirty-one prints titled *Winter in Simla*. The series included images of the Mall in snow (PLATE 20), and of the club from various picturesque vantage points with titles such as a "Peep from Kelvin Grove," or a "Bit Near the Club."

Bourne remained in Simla through the winter and into the spring of 1868, at least long enough for the weather to allow for the image "Picnic Amongst the Trees at Annandale," and at least forty other photographs to be made. It is likely that they didn't leave for more traveling until summer, since most of these latter pictures show trees in foliage.

Ten images made in Umballa just south of Simla indicate some minor travel, or perhaps the start of the trip back toward Bengal. Just over 300 miles north of Calcutta is the town of Darjeeling. Here, Bourne completed at least forty-five negatives, mostly of local attractions, but also including some of the most wonderful forest scenes ever made. The jungle is thickly blanketed with huge ferns and tangles of creepers and vines. The image, "On the Road Around Birch Hill, Darjeeling" (PLATE 21) is a superb vertical composition structured around two immense trees that emerge from masses of underbrush.

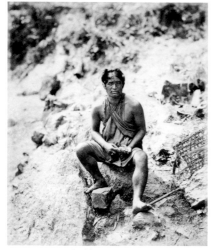

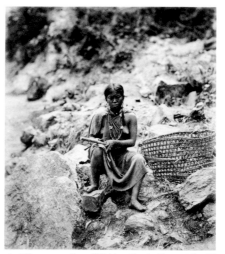

Figure 4. Lepcha Man, native of Sikkim, Darjeeling, 1869. (*Bourne #1907*.)

Figure 5. Lepcha Woman, native of Sikkim, Darjeeling, 1869. (*Bourne #1908*.)

The figure of a native guide in white clothing stands formally within the frame, dwarfed by the scale of the trees and the denseness of the underbrush. The sense of fecundity and explosive vegetative power is strong. The figure of the man is seductive as counterpoint, and as a reminder that man does have a place here, though certainly not a dominant one.

Bourne did very few ethnographic studies, and most of those listed in the B & S catalogue were made by Shepherd, who specialized in what he called "native types." In Darjeeling, however, Bourne made five of the finest portraits he ever made, three of them of groups of Bhooteas. In the superb picture of four adults in local costume in front of a native village house (PLATE 25), the postures are refined, and the gaze of each subject so dignified that Bourne could scarcely have given more power and honor to a royal family portrait. Each figure is given his or her own space against a dark window, doorway or wall; the natives are presented as something other than local color.

The portraits of two natives of Sikkim, "Lepcha Man," and "Lepcha Woman" (FIGURES 4 and 5), are identical in camera placement and exposure. Clearly they were made consecutively, with the woman sitting in the same place as the man had been in the previous image. These are large, direct portraits, with penetrating eye contact. Just as European royalty was often photographed with one foot elevated, resting on a cushion or stool, so too are these tribal individuals seen, right foot placed on a rock. They sit at the center of the image, slightly higher than the camera, again adding dignity to their fine posture. Uncharacteristically, Bourne used a large aperture and allowed the background detail in both images to soften.

Before leaving India in 1869, the Bournes made a little-documented 4,000 mile trip by train and wagon as far as Ootacamund, a typical hill station, and through the Neilgherries (Niligiris), the rolling green hills only 150 miles from the southern tip of India. They also visited Trichinopoly and

Tanjore, two ancient South Indian religious centers, where Bourne photographed the temples and pagodas as well as the great Stone Bull. Bourne made 112 pictures, among which is the "Toda Mund Village and Todas" (PLATE 24). Shortly after the birth of Bourne's first child, Constance Edith, the family returned to England, arriving in late 1869.

After Bourne's departure, Collin Murray was hired to replace him as chief photographer and printer for Bourne and Shepherd. A vigorous young photographer, Murray inherited Bourne's cameras and produced great quantities of images for the firm. Some writers have suggested that Bourne had also photographed in Ceylon, Burma, Malaya and China, but an analysis of the signatures on the plates suggests that they were made by Murray, rather than Bourne, and that the younger photographer was signing them for the firm.

In 1874, the Bourne and Shepherd published a volume of thirty photographs by Murray called *Photographs of Architecture in Amedabad and Rajputana*. In 1877, a book of the *History of the Imperial Assemblage at Delhi* was published, using numerous Bourne photographs done in woodburytype to illustrate the text. The volume served as a program for the festivities surrounding Victoria's assumption of the title of Empress of India. This event, of unparalleled pomp, took place twenty years after the Sepoy Mutiny, and was attended by every major Indian leader in the country. It was quite clear that England's goal of controlling India had been attained.

Even though Bourne was in England, he remained connected with the Bourne and Shepherd firm until 1874. It changed hands several times after that, and is still operating under the same name in Calcutta. The oldest photography firm in India, Bourne and Shepherd is now owned by Indians. All through the 1870s and 1880s, it was the most important photographic firm in India, making portraits of many maharajas, viceroys, governors and other prominent personalities. It

also made the official photographs of the tour of King George V in 1911. By 1940, their catalogue was over ninety pages long and contained "pictures of viceroys, mogul emperors, Delhi Durbars, temples, mosques, architecture, types, Indian industries, Himalayan Scenes, Views of the Khyber Pass and the Andaman Islands."

After leaving India, Bourne's life was drastically changed. A family man, he entered a business partnership with James Boraston Tolley, his wife's oldest brother. The firm was involved in cotton doubling, a method of preparing thread for lacemaking and weaving machines. By 1877, Bourne had formed his own independent company, and by 1880 he had built a large factory, Britannia Mills, which manufactured cotton yarn at Netherfield, near Nottingham. His firm eventually employed hundreds of people. In 1873 a second daughter, Florence Gertrude, was born; a third, Lina Mary, was born in 1874. They had their only son, Stanley, in 1875, and their last daughter, Eveline Annie, in 1879.

Bourne became a wealthy and respected civic leader and watercolorist, and built himself a Victorian brick mansion in the fashionable Park District of Nottingham. He often exhibited his detailed watercolors locally and became the life-long president of the Nottingham Society of Artists. In 1884, the Nottinghamshire Amateur Photographic Association was founded and Bourne was an active member for years. He led discussions, showed prints and lantern slides made in England, and occasionally brought out his old Indian prints. Throughout his later years, Bourne continued to be active in the Nottingham arts community, and in April 1889 he delivered a paper, "Hydroquinone as a Developer," stressing the necessity for the photographer to be well versed in his materials for best results.

In 1893, Bourne lectured to the Nottingham Society of Artists on the "Results of Holiday Rambles with a Camera." Since his audience was predominantly painters, he observed that the medium chosen by an artist mattered little; that the true artist could stamp his individual vision on a photograph or a canvas. Bourne served as vice president of the Nottingham Camera Club from its inception in 1892 until he became its president for a year in 1903. He was actively involved in the photographic surveys of Nottingham made by the club around 1900. In 1902, he showed the club lantern slides of Devonshire and the French Mediterranean Coast, and lectured on "The Two Rivieras," during which he indicated a continuing preference for photographing in England over any other country.

In his later years, Bourne continued his watercolors and displayed them annually in local exhibitions at the Castle Museum. His subjects were often meticulously painted after his photographs. Retiring in 1896, Bourne left his business to his son Stanley. He traveled a bit, became very fond of lawn tennis and was active in his local Unitarian Church. He also became a Justice of the Peace and was a visible member of the community until increasing deafness kept him more and more at home. In his late seventies Bourne's health began to falter. He was well enough to travel to Llandudno in Wales in April of 1912, but several days after his return, on April 24th, a sudden heart attack ended his life. In the presence of a large group of mourners, he was buried on April 27th in Nottingham General Cemetery. His wife, Mary, died seven months later. An oil portrait of Bourne, powerful, wise and direct, with painting palette in hand, still hangs over the main stairway at the Arts Society Headquarters in Nottingham.

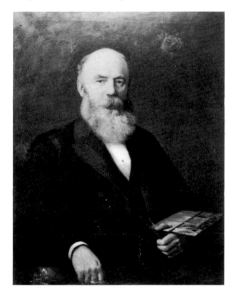

Figure 6. Portrait of Bourne at 54, 1888. Oil painting by George Hodson.

Bourne's contribution to photography was extensive. A superb technician, his work survives today, almost 120 years later, in fine condition. His wet collodion work is exquisite in its formal rendition and its sensitivity to light. No one made more luminous and lustrous prints. His work predates the grand Western American landscape photographs by several years, and there is evidence that albums containing his work, along with that of others, were seen in California during the early 1870s. It is as a composer of photographs that Bourne's skill is dominant, however. His sense of organization of the random environment is as varied, inventive and creative as that of anyone who ever used the medium. He never overpowered the natural setting with compositional devices, but rather, allowed the scene to announce the composition. By trusting photography's inherent logic, he allowed the landscape or building depicted to reveal its own forms. He showed India to be ordered, lovely and manageable, actually taming the wilderness. Photographs such as these helped give the English the interest, desire and justification to hold India. While not necessarily the interest of Bourne, this result was inevitable, just as we own the moon today through photographic evidence.

It is clear that Bourne's work matured greatly in India. By 1866, during the third expedition, he was more influenced by the power of the environment than by mid-Victorian aesthetics. His ability to transcend the picturesque tradition in the Himalayas and create images of lasting power and magnitude; to reconstruct his attitude about the native people; and ultimately, to blend the photographic experience with the rhapsodic experience of transcendent spiritual understanding, all made Bourne extraordinary. Wandering through the wilderness, Bourne redefined in his own language man's confrontation with the timeless, a lesson that, like his albumen prints, is as alive today as it was on the Manirung Pass in 1866.

Arthur Ollman is widely known within the photographic community as an artist, teacher, historian and administrator. One of the founders of Camerawork, a non-profit photography organization in San Francisco, he served as president of the group's Board of Directors before becoming director of the Museum of Photographic Arts in San Diego in the spring of 1983. Ollman's interest in the life and work of Samuel Bourne began in 1970, when he first saw a group of the photographer's prints. The research upon which this essay is drawn was undertaken during the past five years, and was supported in part by a grant from the National Endowment for the Arts.

SELECTED BIBLIOGRAPHY

Bourne, Samuel. "On some of the requisites necessary for the production of a good photograph." *Photographic News*, February 24, 1860.

———. "The Original Fothergill Process." *British Journal of Photography*, January 1, 1862.

———. "Photography in the East." *British Journal of Photography*, July 1 and September 3, 1863.

———. "Ten Weeks with the Camera in the Himalayas." *British Journal of Photography*, February 1 and February 15, 1864.

———. "Narrative of a photographic trip to Kashmir and adjacent districts." *British Journal of Photography*, October 5, October 19, November 2, November 23, December 7 and December 28, 1866, and January 4, January 25 and February 8, 1867.

———. "A Photographic Journey through the Higher Himalayas." *British Journal of Photography*, November 6, November 26, December 3, December 17, December 24, December 31, 1869; January 14, January 28, February 18, March 4, March 18, April 1, 1870.

Bourne, Samuel, and Charles Shepherd. *Photographic Views in India*. London: Howard Ricketts Limited, 19 (catalogue facsimile, no date).

Desmond, Ray. "Photography in India During the Nineteenth Century." *Report for the Year 1974*. London: India Office Library & Records, 1976.

Heathcote, Pauline F. "Samuel Bourne of Nottingham." History of Photography, Volume 6, Number 2, April 1982.

Hutchins, Francis. *Illusions of Permanence*. Princeton: Princeton University Press, 1967.

Taylor, Roger. *Samuel Bourne, Photographic Views in India (1834-1912)*. Sheffield City Polytechnic, England, 1980 (exhibition catalogue).

Williams, Susan I. *Samuel Bourne, In Search of the Picturesque*. Williamstown: Sterling and Francine Clark Art Institute, 1981 (exhibition catalogue).

Worswick, Clark, and Ainslie Embree. *The Last Empire, Photography in British India, 1855-1911*. New York: Aperture, 1977.

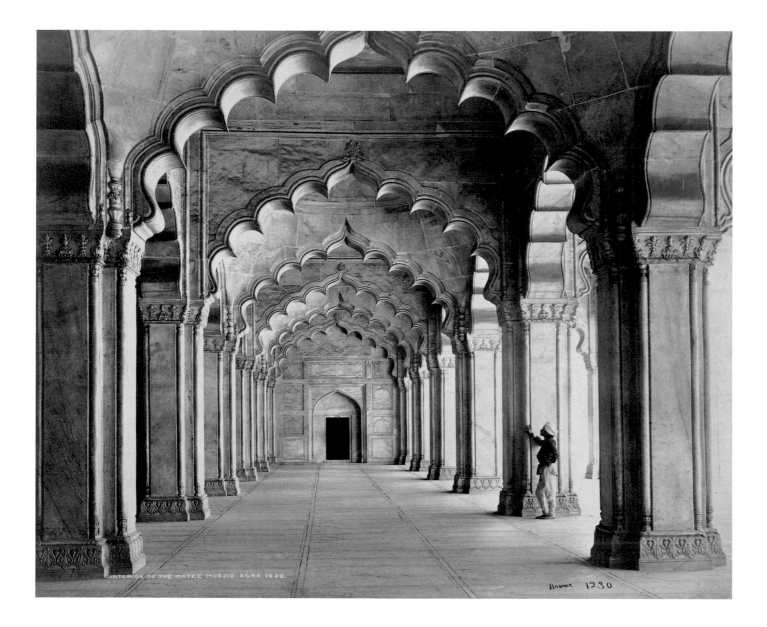

PLATE I Interior of the Motee Musjid, Agra; the Center Aisle, 1865. (*Bourne #1230.*)

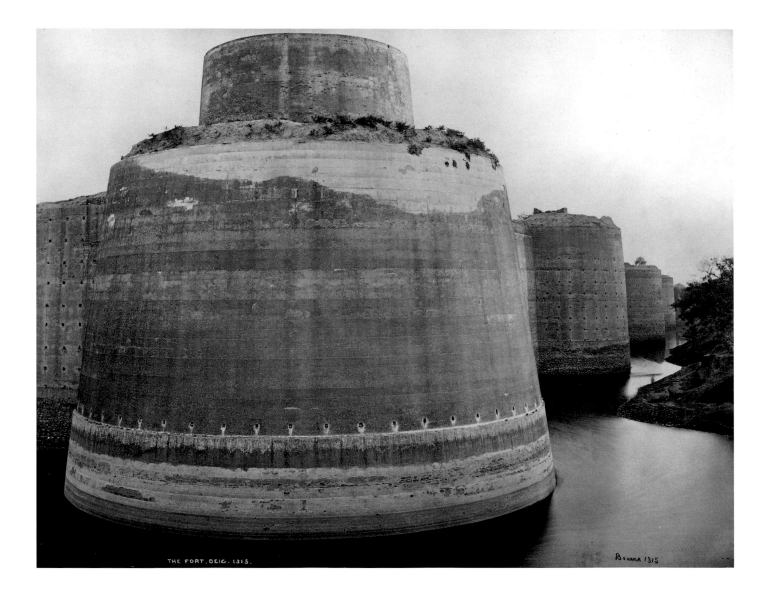

THE FORT. DEIG. 1315.

Bourne 1315

PLATE 2 The Fort from the Northwest, Deig, 1865. (*Bourne #1315.*)

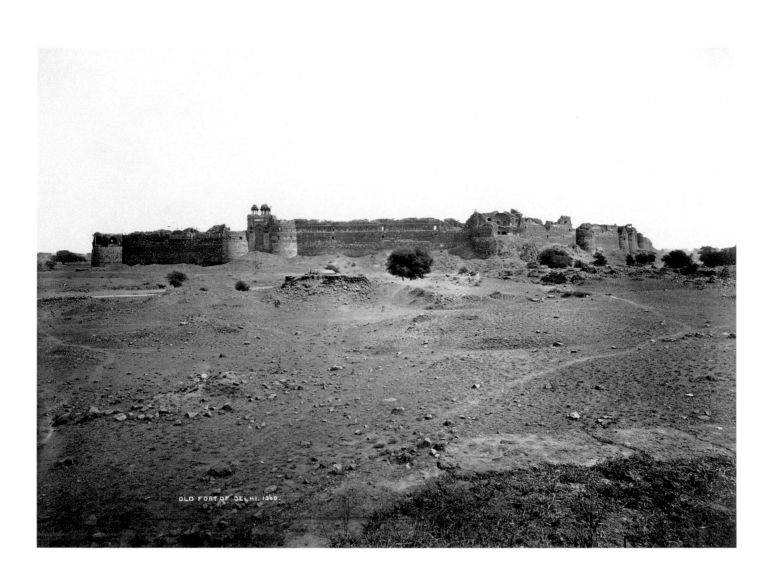

OLD FORT OF DELHI. 1360.

PLATE 3 The Purana Kila, Old Fort of Delhi, 1865. (*Bourne #1360.*)

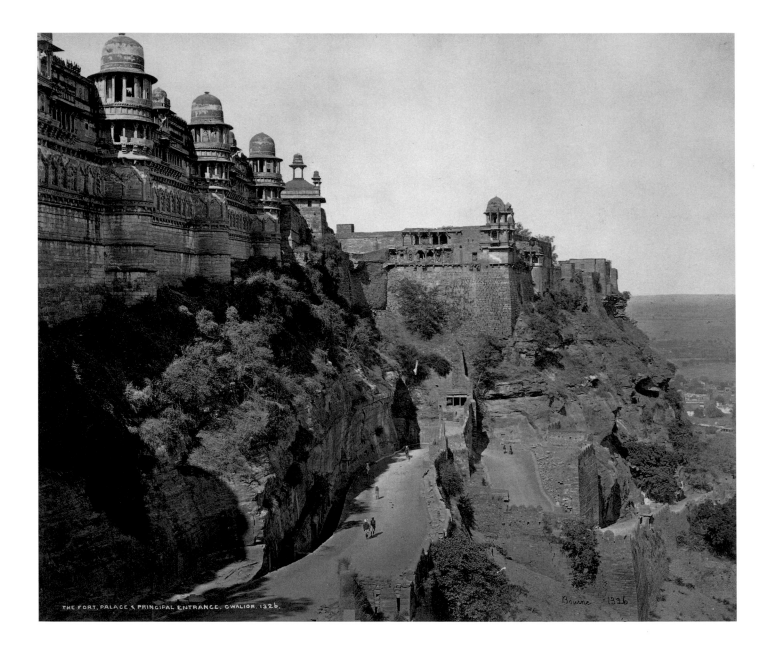

THE FORT, PALACE & PRINCIPAL ENTRANCE, GWALIOR. 1326.

Bourne 1326

PLATE 4 The Fort, the Palace and Principal Entrance, Gwalior, 1865. (*Bourne #1326.*)

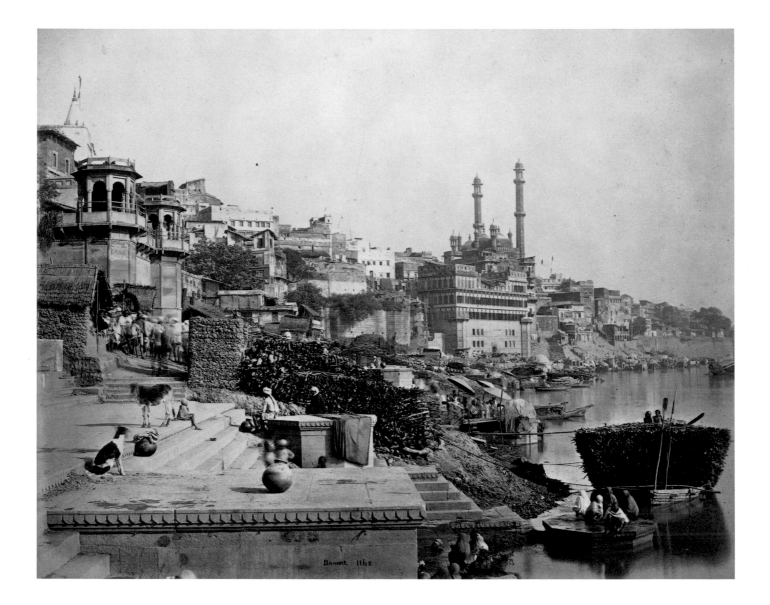

PLATE 5 The Great Mosque of Arungzebe, and Adjoining Ghats, Benares, 1865. (*Bourne #1168.*)

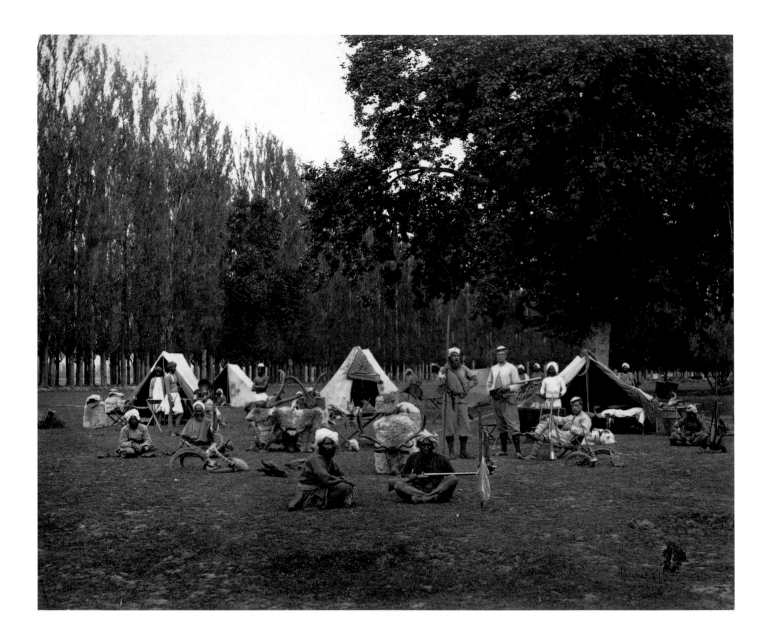

PLATE 6 A Shooting Party in Camp Srinuggur, Kashmir, 1864. (*Bourne #816.*)

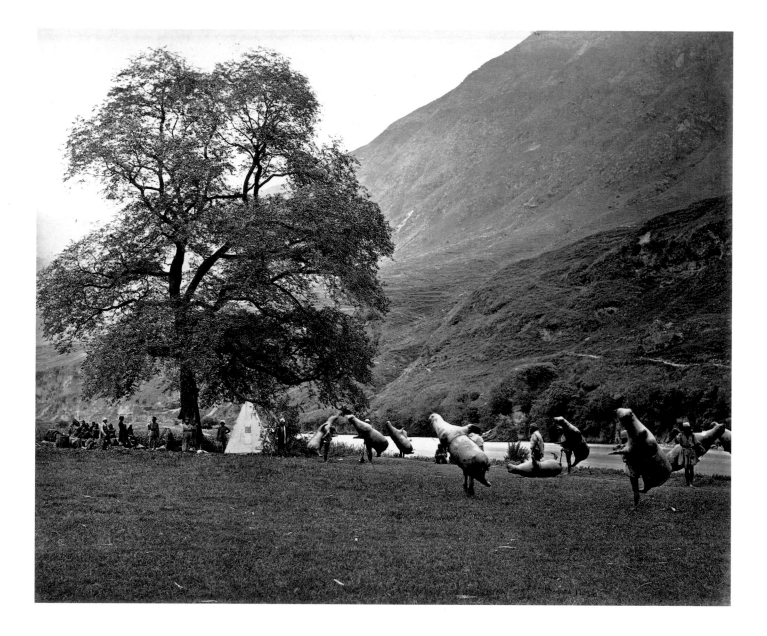

PLATE 7 Mussucks for Crossing the Beas below Bajoura, 1866. (*Bourne #1436.*)

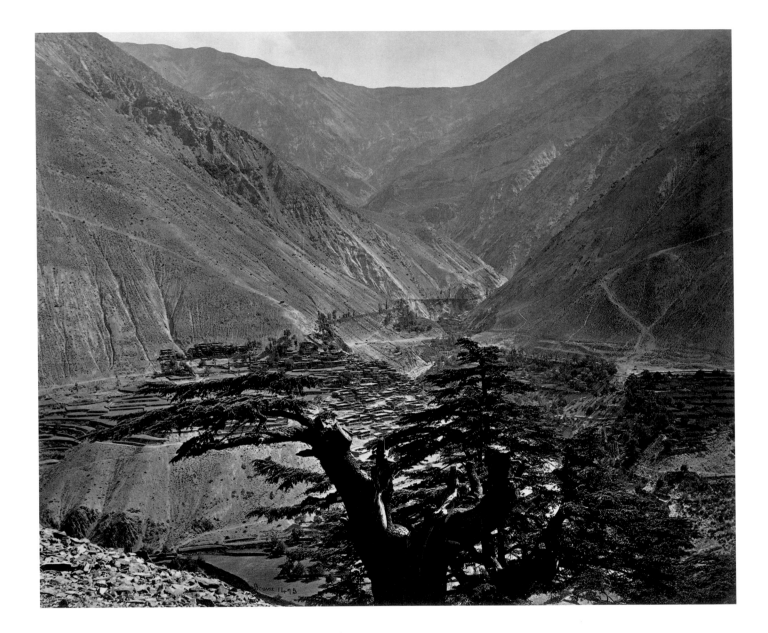

PLATE 8 The Village of Sungnam, with the Hungrung Pass above, 1866. (*Bourne #1475.*)

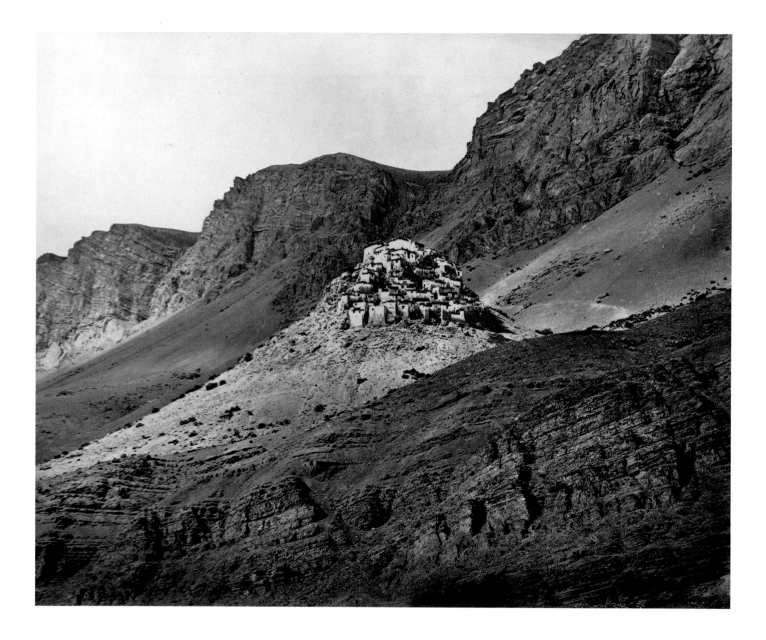

PLATE 9 The Monastery at Ki, Spiti, 1866. (*Bourne #1460.*)

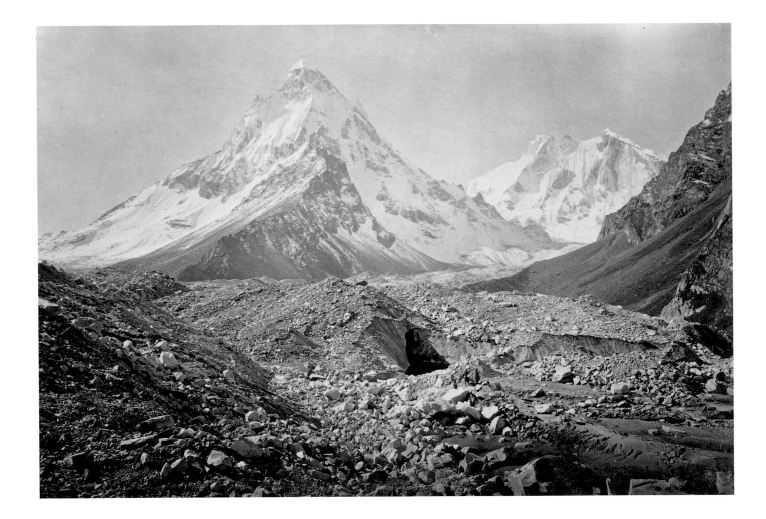

PLATE 10 Mount Moira, and other Snows, from the Glacier, 1866. (*Bourne #1545.*)

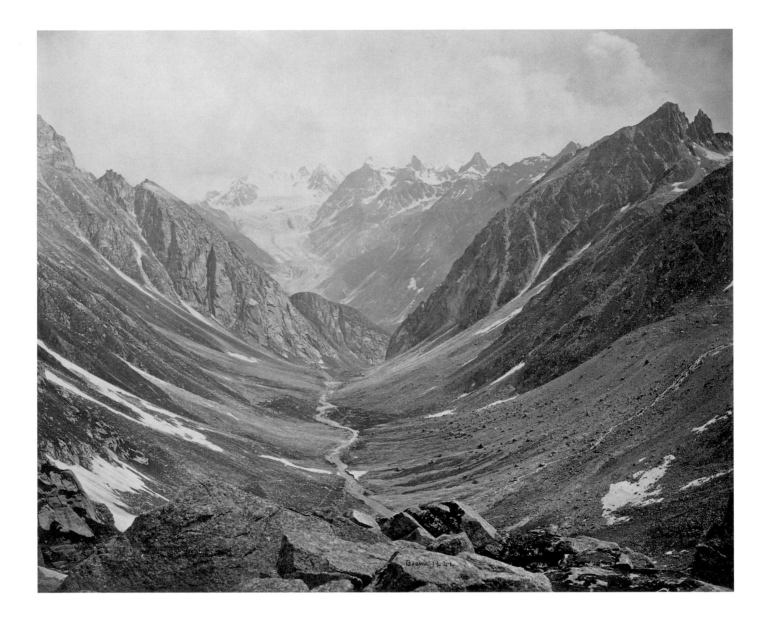

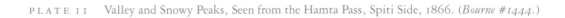

PLATE 11 Valley and Snowy Peaks, Seen from the Hamta Pass, Spiti Side, 1866. (*Bourne #1444.*)

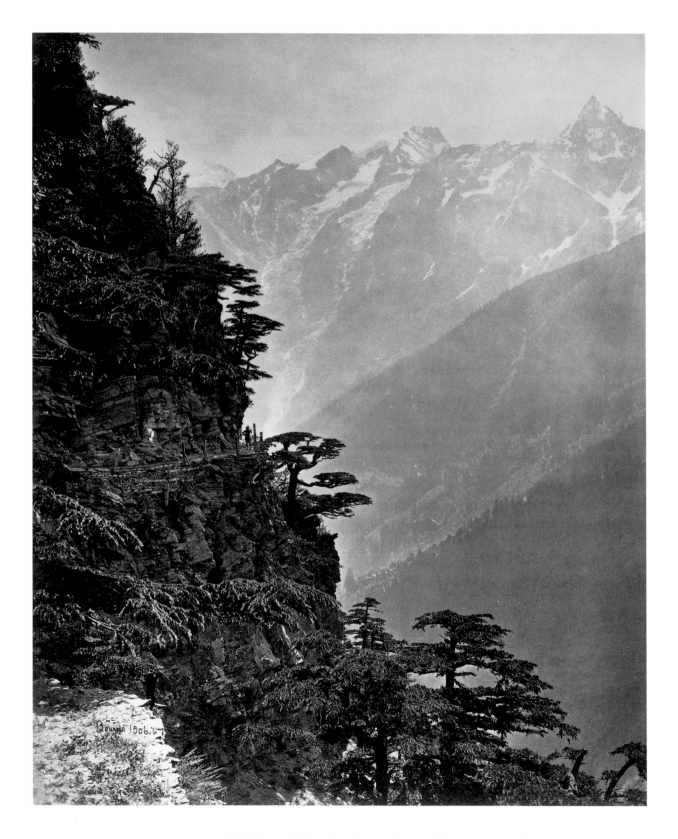

PLATE 12 A "Bit" on the New Road, near Rogi, 1866. (*Bourne #1506.*)

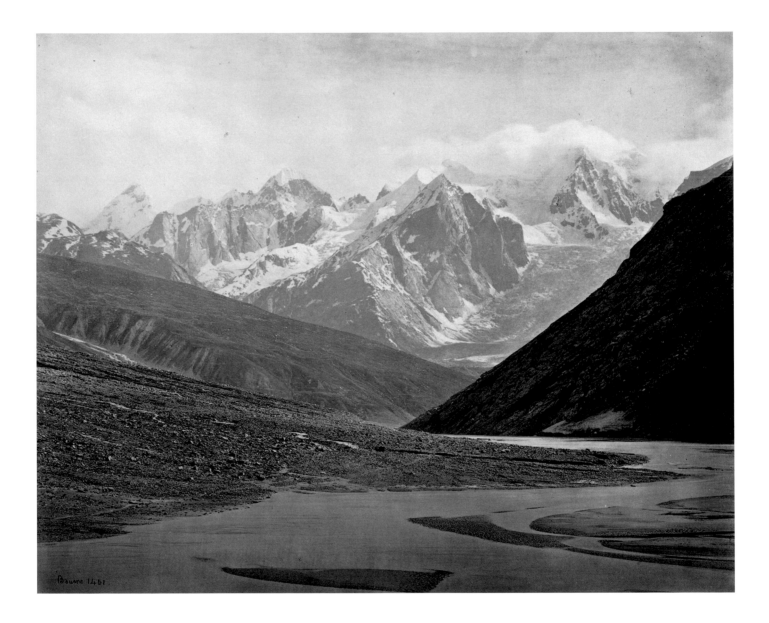

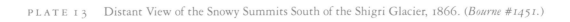

PLATE 13 Distant View of the Snowy Summits South of the Shigri Glacier, 1866. (*Bourne #1451.*)

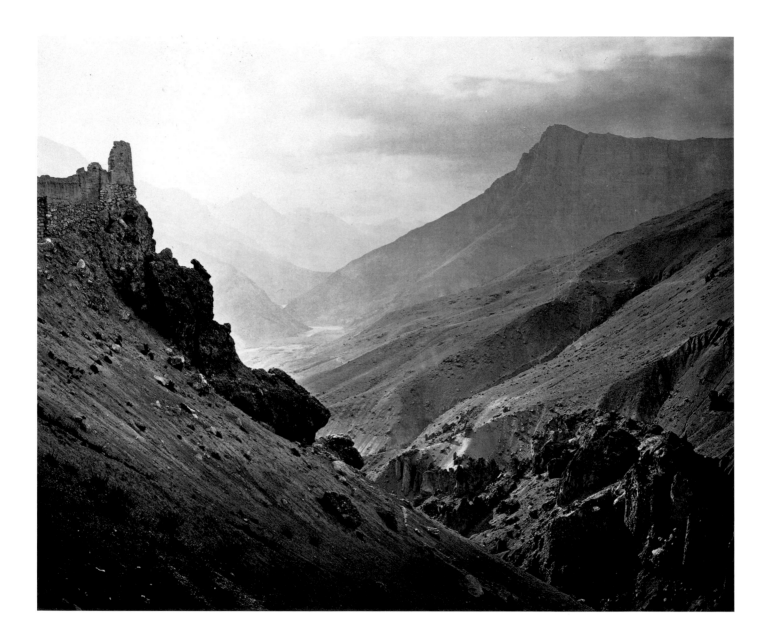

PLATE 14 The Spiti Valley from Dunkar, Evening, 1866. (*Bourne #1465.*)

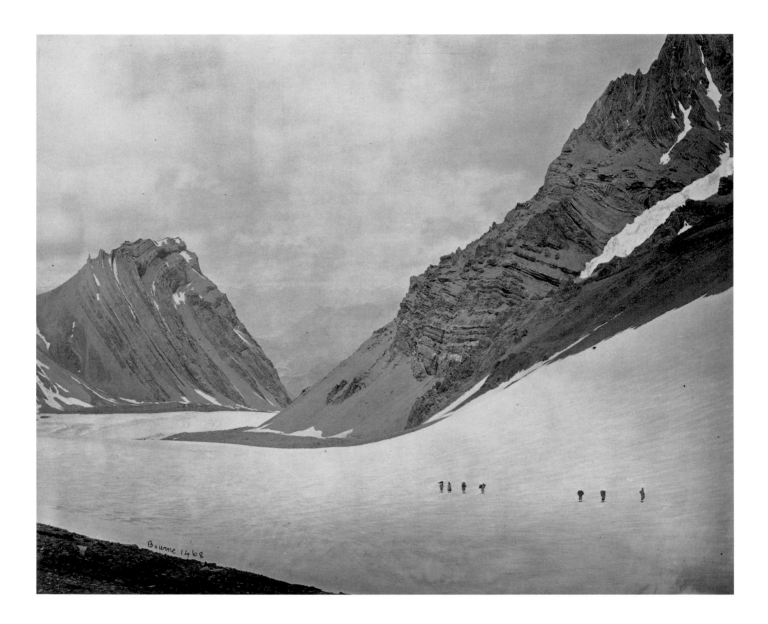

PLATE 15 The Manirung Pass, elevation 18,600 feet, 1866. (*Bourne #1468.*)

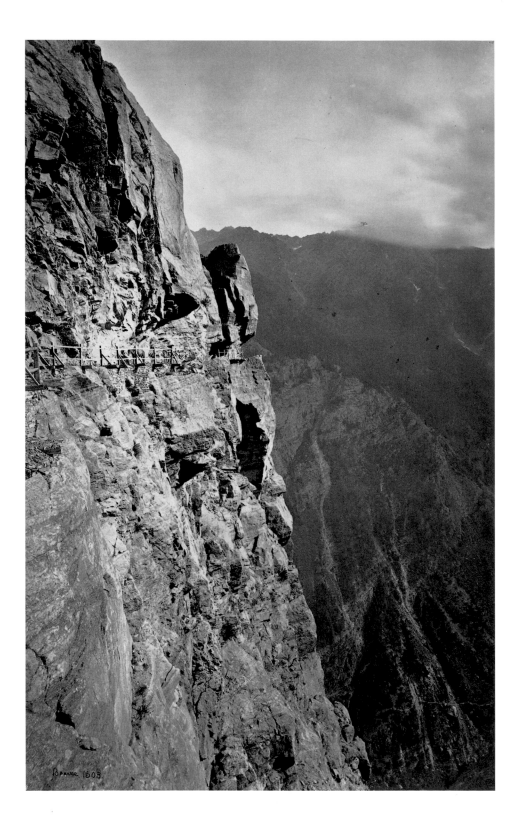

PLATE 16 The Cliff, Near View, 1866. (*Bourne #1503.*)

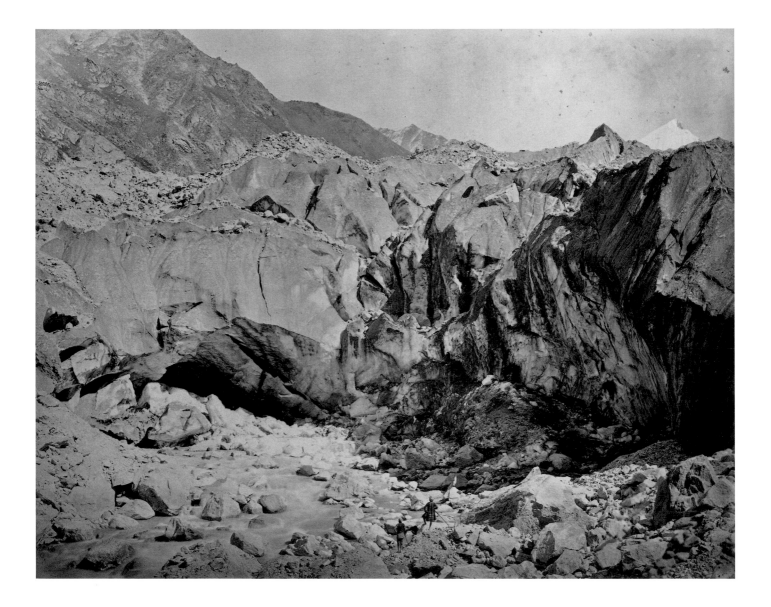

PLATE 17 The Source of the Ganges, Ice Cave at the Foot of the Glacier, 1866. (*Bourne #1543.*)

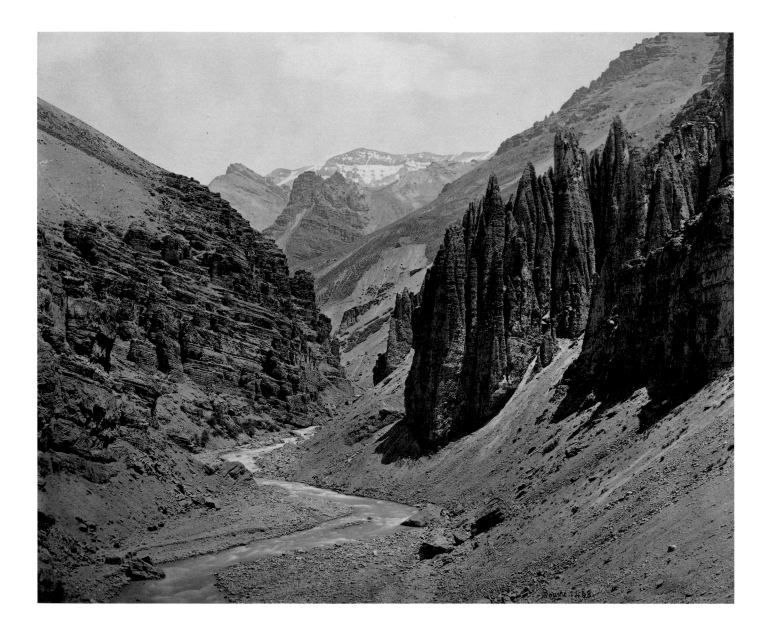

PLATE 18 The Village of Kot, Kulu, 1866. (*Bourne #1428.*)

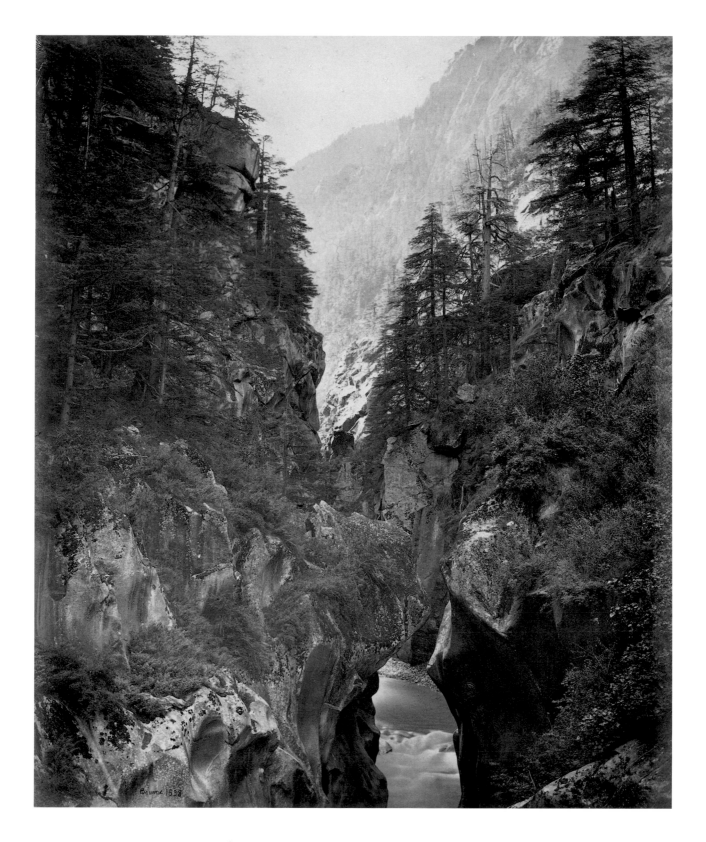

PLATE 19 Rocky Channel of the Ganges at Bhairamghati, 1866. (*Bourne #1538.*)

PLATE 20 Simla in Winter, View from the Bowlee near "Glenarm," 1868. (*Bourne #1772.*)

PLATE 21 On the Road around Birch Hill, Darjeeling, 1869. (*Bourne #1891.*)

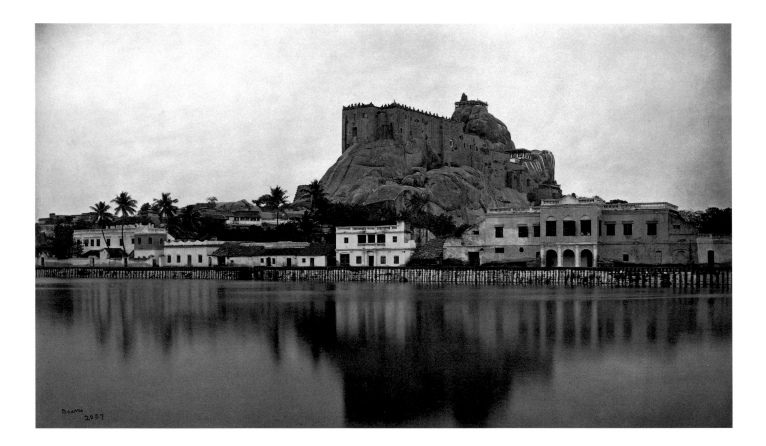

PLATE 22 The Rock of Trichinopoly, from the Tank on the West, 1869. (*Bourne #2057.*)

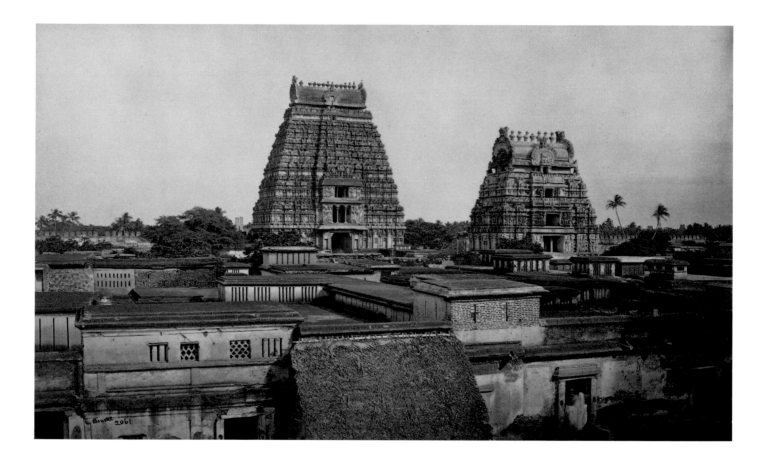

PLATE 23 Two Pagodas from the top of the Thousand-Pillared Hall, Trichinopoly, 1869. (*Bourne #2061.*)

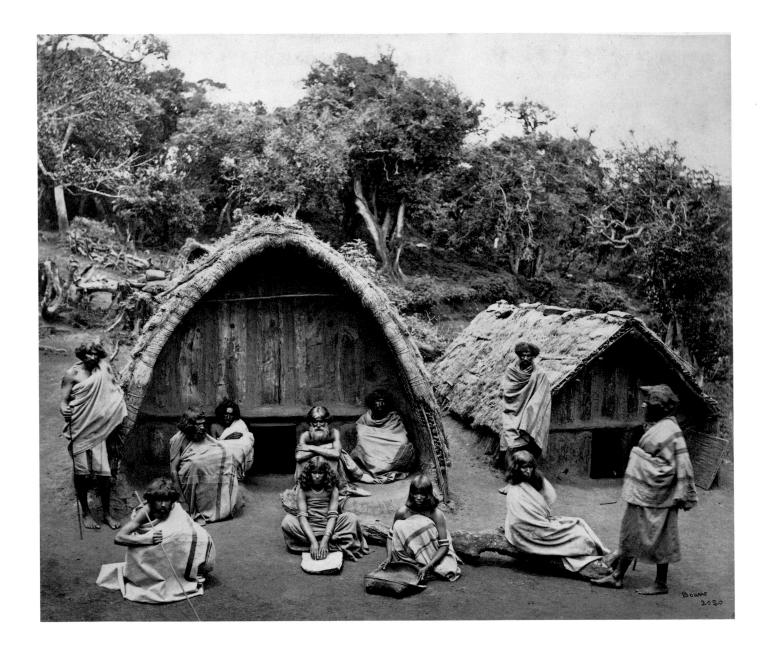

PLATE 24 Toda Mund, Village and Todas, 1869. (*Bourne #2020.*)

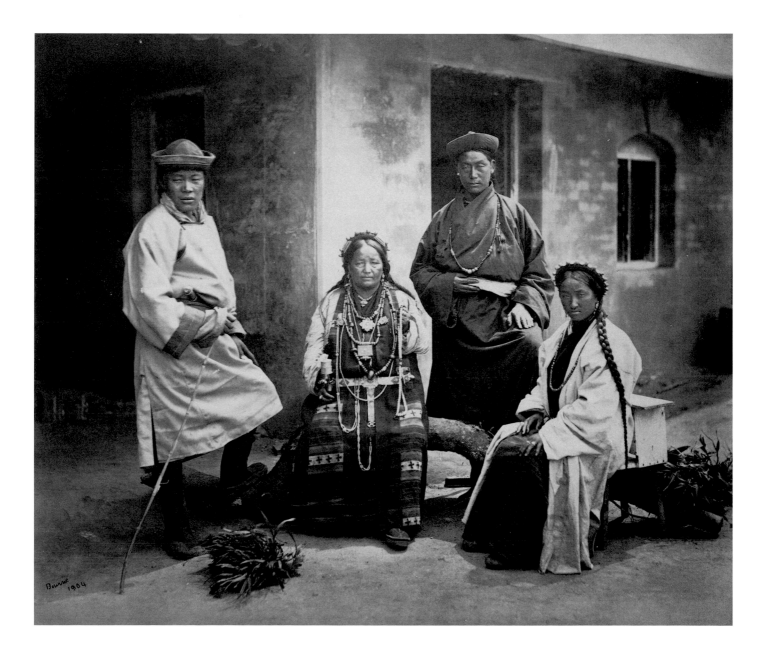

PLATE 25 Group of Bhooteas, Darjeeling, 1869. (*Bourne #1904.*)